EAST TIMOR TESTIMONY

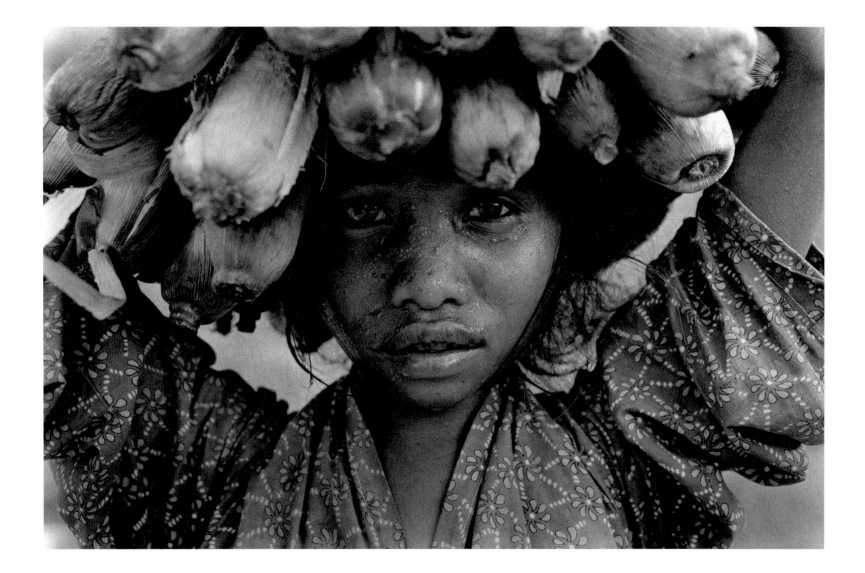

East Timor

TESTIMONY

PHOTOGRAPHS BY ELAINE BRIÈRE

BETWEEN THE LINES
Toronto, Canada

East Timor: Testimony

© 2004 by Between the Lines

First published in Canada in 2004 by
Between the Lines
720 Bathurst Street, Suite #404
Toronto, Ontario M5S 2R4
1-800-718-7201
www.btlbooks.com

National Library of Canada Cataloguing in Publication

Brière, Elaine, 1946–
 East Timor : testimony / photographs by Elaine Brière.

ISBN 1-896357-89-X

 1. East Timor. 2. East Timor–Pictorial works.
 I. Title.

DS649.3.B75 2004 959.87 C2004-901091-3

Frontispiece: Hill tribes girl carrying corn, 1974
Cover and text design by David Vereschagin, Quadrat Communications
Printed in Canada by University of Toronto Press

Between the Lines gratefully acknowledges assistance for its publishing activities from the Canada Council for the Arts, the Ontario Arts Council, the Government of Ontario through the Ontario Book Publishers Tax Credit program and through the Ontario Book Initiative, and the Government of Canada through the Book Publishing Industry Development Program.

To the souls of the dead resting in Mount Matebian, and to the memory of those who responded to the call: Michele Turner from Australia; Michel Robert from France; Kamal Bamadhaj from Malaysia; and Bill Owen from Nova Scotia.

Contents

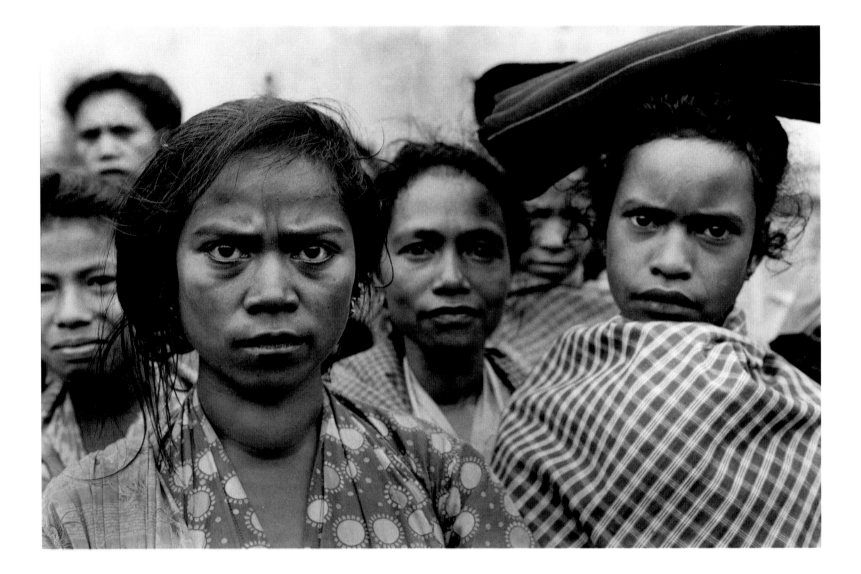

Whether or not total genocide occurs in East Timor depends not only on the remarkable powerful will of the Timorese people, but on the will of humanity, of us all.

Kamal Bamadhaj, 1970–1991

PRELUDE

ELAINE BRIÈRE

Preface

It was April 1974. We were flying over the mountainous interior of Portuguese East Timor. From the airplane window I could see the small villages perched on hilltops, surrounded by gardens and jungle – they seemed to be straight out of a fairytale. I loved East Timor from the start.

We landed on a dirt airstrip in a theatrical cloud of dust, disembarked under the curious gaze of a group of brown-skinned children and caught a ride to Baucau in an army jeep driven by a Portuguese soldier.

My travelling companion, Nicola Murphy, had arrived a few days earlier. I found her sitting on the market steps in the shade with a group of red-lipped older women chewing betel nut.

It was Sunday, a market day in Baucau. Villagers came from all around to sell, to barter, to swap gossip, and to visit with relatives and friends. Dried fish hung alongside bright-coloured weavings. Most sellers displayed their wares on woven cloths on the ground: pottery, corn, tobacco arranged in neat piles, chickens, pigs, baskets, hats, beautiful tortoiseshell combs, and a bewildering array of vegetables and exotic fruits.

The Timorese sat comfortably on their haunches, talking, smoking, chewing betel nut, curious but cautious. Foreigners seldom visited East Timor in those days. I didn't take any photographs that day, but was excited by the prospect. I had no idea that the images I would take over the next three weeks would become part of a worldwide campaign to free East Timor from a cruel Indonesian occupation that began eighteen months later.

In 1974 Portuguese East Timor was a forgotten remnant of a fading empire, a sleepy colonial backwater. It was a place where the Salazar regime sent dissidents and promptly forgot about them. There were only about four hundred Portuguese soldiers in Timor. We sometimes saw them sleeping at their posts or making half-hearted marches around town just to remind the Timorese that they were still in charge.

Visiting East Timor then was like stepping back in time, into a mysterious and hidden world, a place of stoic discipline and stunning beauty, dark secrets, and strong sensuality, a place where unknown smells and sounds flooded the senses and stirred the imagination. People walked up steep mountain paths with heavy items on their heads as if it was the easiest

thing in the world. I loved the sound of water everywhere and the gigantic proportions of the vegetation. The nightly display of the moon and the stars was dazzling.

As we travelled across the island in the back of army trucks and Chinese lorries we began to appreciate the extraordinary cultural and linguistic diversity of the Timorese. Here Polynesian and Melanesian influences from the East met Malay and Asian influences from the West. Besides Portuguese and Hakka (a Chinese dialect), thirteen indigenous languages were spoken. Before the Indonesian occupation, anthropologists from all over the world came to study Timor's rich cultural history. Some, but not many, later became active on their behalf in the solidarity movement.

For about ten days we were the accidental guests of a seaside village below Baucau. The sun sets quickly in the tropics. Nicola and I were on the beach one afternoon when it got suddenly dark. We were unable to find the footpath back to town. We were discovered by a young Timorese woman, who remembered Nicola from an earlier visit. Fatima took us home to her village and presented us to her mother. The next day "Mama" insisted we fetch our things and stay with them. In Mama's mind we were "lost" in East Timor, without family and in need of protection. We were only too happy to leave our shabby hotel, where howling dogs kept us awake at night. We moved into a cool bamboo house surrounded by palm trees on a breath-taking white sand beach, where we were lulled to sleep each night by the sound of waves lapping against the shore.

Nicola and I were treated warmly by Fatima, her bother Luis, Mama and Papa, and the thirty or so relatives who drifted through on a regular basis. They washed and mended our clothes, fixed our hair in a proper bun behind our heads, and made us excellent coffee every morning. We drank it while we watched Luis climb a palm tree, make a small cut at the top of the trunk, and fix a bamboo container to fill with frothy palm wine for the afternoon break.

One day Mama took us to visit her maternal village, a two hour climb straight up a steep hill. The village was nestled back from a ledge overlooking the ocean a very long ways down – a truly thrilling view. There was a women's house at one end of the village and a men's house at the other. Before the noon meal, for which the village elder killed a chicken in our honour, we lay down to nap in the women's house. I'll never forget the delicious sense of peace and contentment I felt dozing off to the soft sounds of women chatting and babies nursing.

We awoke to the smell of stewed chicken. We ate it with rice and chilies and afterwards wandered around the village while Mama visited her relatives. There were about eight individual family dwellings in the village, all very close to one another. We watched women making baskets. I took a few photographs of the children. No one seemed rushed or in a hurry. There were no unemployed or unwanted people in the village. Everyone, even children, had special tasks such as minding younger children, foraging for firewood, or helping their grandparents. Though the cash income for this group of families was very small, they lived a relatively comfortable lifestyle in close relation to their surroundings. It was this intimate knowledge of the land and its resources that enabled many Timorese to survive the Indonesian occupation.

Early one morning about a week after we had arrived, we approached the steep path up the beach to Baucau. We heard male voices singing in the distance, growing louder as we neared the rice fields. As we emerged from the forest, we saw two young men, naked to the waist, knee-deep in mud, singing to their teams of buffalo as they trudged around the rice paddies, breaking up the soil for planting.

Eighteen months after we said good-bye to this tranquil village, Indonesia invaded East Timor in a brutal land, sea, and air assault. I was back in Canada. A friend brought a newspaper with headlines about the invasion, down to the dock where I was living on an old yacht. I was stunned. It seemed like only yesterday that we had parted from Fatima, her brothers, and her parents. Images of the men singing the rice fields, Fatima pounding rice for the evening meal, and Mama's cliff-top village came to mind. I couldn't imagine why the world would let this happen. What possible threat could East Timor be to Indonesia?

At the time I poorly understood the connections between the rich western countries, and exploited countries like Indonesia. My education began after reading "The United States and East Timor" by Noam Chomsky (now available in *Towards a New Cold War: Essays on the Current Crisis and How We Got There*). I wrote to him that I had been there in 1974 photographing village life. Unbeknownst to me, the solidarity movement was desperate for images of East Timor. Calls began to come in. Books, newspapers, academic journals, posters, and pamphlets in many countries used these photographs. Exhibitions of the photos I had taken in East Timor toured the U.S., Holland, Portugal, Japan, Australia, Sweden, Germany, and the United Kingdom. In a very short time I became involved in the international human rights and solidarity movement for East Timor.

After discovering my own country's duplicitous role in supporting the Indonesian occupation I began to work with the Canadian churches to set up a Canadian solidarity group. We started the East Timor Alert Network (ETAN) in 1986. These were dark and frustrating years. Indonesia had a powerful lobby in the business community. Most western countries, including Canada, were deaf to the pleas of the East Timorese. When I went to the United Nations I was shocked to find that the Canadian mission was actively supporting the Indonesian occupation, downplaying atrocities, and promoting the false idea that Indonesia was bringing education and prosperity to East Timor.

There were times when it didn't seem there was much hope for Timorese independence. The western countries were very close to the Suharto regime. Business was booming. But the Timorese never faltered, never once gave up the struggle to be independent and repel the Indonesian invaders. And when a window of opportunity opened with the fall of the regime, they took it. With the Indonesian army still in occupation, they declared their desire to be an independent country, in a United Nations referendum in August 1998.

I went back to East Timor in April 2000, twenty-six years after my first trip. I travelled with German journalist Klemens Ludwig, who had worked tirelessly on East Timor for many years. The first thing I did was to return to Baucau to see if I could find Fatima's village. I wasn't hopeful. The Danish report on the fate of the residents of Baucau and surrounding hamlets was grim. After the Indonesian troops raped and killed those who hadn't fled to the mountains, they torched and burned the houses to the ground. Surely Fatima's home did not escape.

I took the tarmac road the Indonesians had built to the beach and found the place where Fatima and her family had lived. The village was gone. Gone too was the stand of palm trees that sheltered the houses from the sea. Only the beach and the creek remained. Thatch houses, inhabited by fishing families, were scattered here and there. A little girl was gathering firewood by the creek. A woman chased her goats home at dusk. I stopped to watch a man and his young son chopping coconuts in half with one quick stroke of a machete. I had the feeling of being in a dream, watching the ghosts of the Timorese who had lived there in 1974. Later, when I spoke to Bishop Basílio do Nascimento of Baucau, he said that it was

extremely unlikely that any of the original inhabitants of the village had survived.

Hitching a ride with Jesuit Relief Services, I visited the eastern rice-growing region of Maliana and photographed farmers taking in the first rice crop after the Indonesian occupation. There was a large work party of about seventy-five people. Women were cooking the noon meal under a thatched-roof shelter at the edge of the rice fields.

The town of Maliana, near the Indonesian border with West Timor, has a spectacular view of fields and distant peaks. Like Dili, the town was virtually burned to the ground in the violence following the August 1999 referendum.

Many people in Maliana wore black, or a little square of black cloth pinned to their clothes, in mourning. I photographed the relatives of those who were killed, with the help of two young Timorese men, Fideles and Roberto. Both had lost their fathers to pro-Indonesian militia. The families searched for photographs of their sons and husbands. They showed me their graves, lovingly placed close to the house. Tears streaming down their faces, they pointed out the locations, marked by rocks, where their loved ones had been killed.

Fideles and Roberto took me to the Indonesian police station where eighty men had been executed in one day, Roberto's father one of them. One woman, Angelina da Conceição, lost the last of her three adult sons. She had no more tears left as she held up fragments of photographs for me to see. The people in Maliana wanted the world to know what had happened in East Timor.

I had mixed feelings when I left. Though I was happy that the Timorese could walk freely in their own land once again, so many lives had been lost, and so much damage done, that it would take decades to recover. The leadership was new and inexperienced. The tranquil seaside village of Likisa and other places were targets of Western-style tourism that could destroy the livelihood and sense of well-being of the people living there.

In spite of all this, isolated from the outside world, unified across diverse racial and linguistic lines, this small nation of mostly hill tribe farmers won its freedom. Nothing can take this remarkable achievement away from them.

These photographs are dedicated to the enduring spirit of the people of East Timor, and to all those around the world who refused to abandon the Timorese in their darkest hour. And to the widows of Maliana, may your tears not be in vain.

ACKNOWLEDGEMENTS

I would especially like to thank Stephen Dale, who first suggested the idea of this book, and introduced me to my publisher Paul Eprile, who has been a pleasure to work with.

German journalist Klemens Ludwig, dedicated supporter of East Timor for many years, invited me to accompany him to East Timor in 2000, enabling me to compete this body of work. Jack Panozzo, Barb and John Taylor, and Peter Gillespie wholeheartedly supported this project right from the start.

I am indebted to David Webster for his loyalty, to Jane Springer for her patience, to Celine Rumalean for her careful translations, and to David Vereschagin for his pleasing design of this book.

For their support and inspiration over the years, I would also like to thank the following people: Daniel Devaney, Jillian Skeet, Mark Achbar, Kim Fagerlund, George Martin-Manz, Manfred Becker, Brooks Kind, Carol Foort, Tony de Castro, Stephen Langford from Australia, and António Barbado Magalhães from Portugal. ■

DAVID WEBSTER

Introduction

I first saw one of Elaine Brière's photographs in Peterborough, Ontario in 1985. The image was a close-up of a Timorese girl carrying corn on her head, staring straight at the camera. Straight at me. Her face dominated a poster stapled to a hydro pole, which advertised a talk on East Timor by Noam Chomsky.

East Timor? I'd never heard of it. It hadn't been taught in high school. There weren't any courses on it at my university. So I passed by and didn't go to the talk, one of two Chomsky was giving that day to mark the tenth anniversary of the Indonesian invasion of this island country.

But I couldn't forget the picture of the girl whose eyes seemed to say: Why? Why has this been allowed to happen to my country?

That's the thing about Elaine Brière's art. Although they have been displayed in prestigious galleries from Sweden to Japan, her photos are far more often seen on advocacy posters, in cheaply produced newsletters, in magazines run on a shoestring. That takes nothing away from their power. No matter how many times they are photocopied they lose none of their evocative beauty. Elaine never worried about whether she was an artist, a photojournalist, or an activist. She never hesitated to give these images freely as a tool for advocacy. It's as if she never thought of the photos as something that belonged to her. They belonged to the people in the picture, to a people who could not speak for themselves no matter how they shouted, since the Indonesian army kept East Timor sealed shut, tightly, and Western governments and media kept their ears shut, just as tightly.

And so Elaine's photographs became ambassadors for a country brutally silenced. There is a story of the Mambai, the indigenous people of the central mountains of Timor, that tells it best. The Mambai believe the cosmos is made up of two categories: silent mouths and speaking mouths. In the beginning, all things spoke. Grass shouted in pain when people walked on it. Trees cried out when they were cut. The earth itself was wounded when it was farmed. So Father Sky made them all fall silent. Only his youngest children, human beings, were left as "speaking mouths." But in return they owed restitution, an obligation to speak for the voiceless "silent mouths," their elder kin, the rocks and trees.

When the people of East Timor were silenced, not by Father Sky but by the powerful armed forces of Indonesia, Elaine's photos became in a sense "speaking mouths." The Timorese could not speak, but their images spoke forcefully.

These images came about almost by accident. Elaine was travelling the "hippie trail" through Southeast Asia when she found herself in East Timor in April 1974. She fell in love with the island and its people. Most of the photos she snapped then are anonymous. They show village life in places like Baucau, Lospalos, and Manatuto. Women are going to market, men are fishing, boys are tending the ubiquitous pigs. The only subject that recurs is Fatima, the young woman whose parents opened their home to Elaine. She doesn't know what befell Fatima twenty months later, when village life was shattered by the Indonesian invasion.

When Elaine visited thirty years ago, East Timor was still a neglected colony of Portugal, the last European power to give up its colonies. That month, however, soldiers tired of fighting colonial wars in Africa toppled the Salazar-Caetano dictatorship, sparking a period of political freedom called the "Carnation Revolution." The new government announced that the colonies would be allowed to decide their own future. By 1975, all five African colonies had their long-sought independence.

East Timor was set on the same path. Three political parties were formed now that the feared PIDE secret police were no longer active. The Timorese Democratic Union (UDT) was the political vehicle of the assimilated elite. It wanted eventual independence in association with Portugal. The Revolutionary Front for an Independent East Timor (Fretilin), modelled on independence movements in the African colonies, wanted independence as soon as possible and espoused a mixture of Catholic nationalism and rural popular education programs like those pioneered in Brazil by Paulo Freire. Fretilin thrived, with a focus on indigenous values and the creation of a new political culture through images like the Maubere – a term of

contempt used by the Portuguese for the "primitive" Mambai – which Fretilin adopted as a badge of pride. The Association for the Integration of East Timor into Indonesia soon changed its name to the Timorese Popular Democratic Association (Apodeti), but its goals remained clear.

In 1975 the three parties faced off in the territory's first free elections, for municipal councils. Fretilin took 55 per cent of the vote, the UDT most of the remainder. Apodeti was a distant third. Fretilin's rural popularity surprised the other parties, as well as Indonesia, which stepped up covert operations. In August the UDT staged a coup but Fretilin fought back and drove the coup group across the border into Indonesia. There, UDT leaders were forced to sign a declaration drafted by Indonesian intelligence operatives that was used to justify Indonesian army attacks across the border and eventually full-scale invasion. Fretilin begged the Portuguese to return and supervise the decolonization process, but there was no response. On November 28, 1975, Fretilin leaders gave up on the Portuguese and declared independence. Indonesia called the new government communist; journalists on the spot said it looked more like the graduating class of Dili's seminary school.

Indonesia for years had promised not to invade East Timor. Foreign Minister Adam Malik told Fretilin's José Ramos Horta: "The independence of every country is the right of every nation, with no exception for the people of Timor." President Suharto also promised that Indonesia "does not have territorial ambitions, let alone plans to include the territory of Portuguese Timor with the territory of the Republic of Indonesia."

On the morning of December 7, 1975, twenty-three Indonesian warships anchored off Dili, the Timorese capital, with a population of just 12,000. They began to bombard the city and the hills behind it. At the same time, hundreds of paratroopers were dropped over the city. Up to 15,000 Indonesian soldiers were involved in the attack. It was the largest

military operation in Indonesian history – yet none of the soldiers wore the uniform of the Indonesian army. The Suharto regime claimed they were "volunteers."

The Fretilin radio broadcast an appeal for help. "The Indonesian forces are killing indiscriminately," it said. "Women and children are being shot in the streets. We are all going to be killed. I repeat, we are all going to be killed.... This is an appeal for international help. Please do something to stop this invasion."

Nothing was done. In fact, the invasion was approved in advance by the governments of Canada, the United States, Australia, and others. In July 1975, six months before the invasion, President Suharto and Foreign Minister Malik visited Ottawa and Washington. Suharto had a private meeting with Prime Minister Pierre Trudeau, with the "question of Portuguese Timor" on the agenda. At this meeting, Canada gave Indonesia a $200-million line of credit. The Trudeau foreign policy was resolutely anti-communist, while it also aimed at international development of the type fashionable in the 1970s – megaprojects directed by often corrupt and unrepresentative regimes. On both grounds, Indonesia was a friend of Canada.

In Washington, Suharto told President Gerald Ford that Indonesia would not use force but "the only way is to integrate into Indonesia." But Indonesian forces attacked not long after Ford and his Secretary of State Henry Kissinger gave them the nod in a December 1975 visit to Jakarta. As Noam Chomsky explains in his essay in this book, the United States remained a willing accomplice throughout the period of Indonesian occupation.

Speaking from his experience with East Timor, which spans more than half a century, James Dunn, in his essay, demonstrates that Australia also backed the occupiers. So did most of the world's powers, great and small alike – including Canada.

Two days after the invasion of East Timor, a Conservative backbencher asked Trudeau whether Canada would protest against the invasion by halting a pulp mill planned for Indonesia. "I do not share the honourable member's premises," Trudeau replied. Over the next ten years, only two MPs spoke on human rights in Indonesia and East Timor. But Canadian aid and investment increased rapidly as the death toll mounted in East Timor.

Human rights groups and church sources have tried to estimate the death toll. Amnesty International pegged it at 200,000, almost one third of the population. It is a number that can hardly be comprehended. It tells nothing of the lives of those who survived. That is the subject of "Timor, Where the Sun Rises," by Merício Juvinal Dos Reis (with Endah Pakaryaningsih), in this book. Or hear the words of Martinho da Costa Lopes, East Timor's Bishop in the 1980s:

People came knocking at my door in the day and the night, for years, whispering of terrible things. From 1975 the Bishop's residence was full of girls seeking refuge. In the Comarca prison were women who had all been raped and abused. They told me when I spoke with them. We heard constantly of young girls being abused by soldiers. The Indonesians often use Timorese not as people but as toys, young girls especially. They see a beautiful girl they want, after they have used her they ignore what has happened to her, like a child with a toy....

It was common in 1980–81 to take groups of people after an interrogation up in a helicopter from Lospalos to Jaco (a little island) and drop them to smash there, or to fly over the sea and drop them. Some Timorese had to go with the soldiers to help them do that. Many people I know have been tortured with electric shock. It is a terrible thing, it shows no respect for human dignity....

Some of these sorts of things I hear make me think they are quite mad, these soldiers. They seemed to have no moral sense, no humanity. One of their favourite customs was to rape the wife in front of the husband, right there, sometimes the children there too. For Timorese people, worse than physical suffering was the moral suffering of those things, the humiliation, the taking away of the dignity of people. I said to Indonesian officers, "Don't you have mothers, sisters, do you know what it is to be human?"

When a Canadian parliamentary delegation visited East Timor in 1987, the delegation chief reported that "we did not see any strange or illogical problems in the area.... Frankly what we saw made us proud as human beings." Throughout the late 1970s and the 1980s, East Timor remained closed to the outside world. The only Timorese who could be heard in Canada were those in Elaine Brière's photographs.

Despite conditions in East Timor and the apparent hopelessness of their cause, East Timorese continued to resist. Some joined the Falintil (Forças Armadas da Libertação Nacional de Timor-Leste), the armed wing of Fretilin, and became guerrillas, a living symbol of Timorese independence. "To resist," said their commander Xanana Gusmão, "is to win." Others organized clandestinely in towns controlled by the Indonesian army, smuggling food to the guerrillas and news to the outside world. Still others made contact with sympathetic Indonesians – university students, non-governmental organizations, yearners for democracy who would later become the nucleus of the movement that toppled the Suharto dictatorship. A new generation of resistance grew up under military occupation: the products of Indonesian indoctrination were even more determined to resist than their parents had been.

As the word trickled out, solidarity movements began to be formed around the world, bringing together a small band of diverse and dedicated individuals inspired by the courage and determination of the East Timorese and appalled by their own governments' complicity in genocide. The solidarity movement story is chronicled in Elaine's photos and in Carmel Budiardjo's essay in this book.

In November 1991, Indonesian soldiers massacred over two hundred protesters at the Santa Cruz cemetery in Dili. This was not unique, except that it was filmed by foreign journalists. One foreigner was among those killed: Kamal Bamadhaj, a Malaysian who held New Zealand citizenship. The images of terrorized young Timorese fleeing the Santa Cruz massacre were screened around the world, providing a spur to international solidarity. Support rose further when East Timor Bishop Carlos Belo and José Ramos Horta won the 1996 Nobel Peace Prize. Actions like the effort by Canadian activists to have President Suharto arrested at the 1997 APEC summit in Vancouver became more and more common.

In an occupation that lasted a quarter of a century, one person in three died as a direct result of Indonesian military occupation. Yet the East Timorese did not give up hope. Within a year of the Suharto regime's collapse in 1998, the new president agreed to the long-standing demand of the East Timorese resistance movement, a referendum that would finally give them the choice they had been denied for so long – independence, or integration with Indonesia. The United Nations was to hold the referendum, but tragically, Indonesia's army remained responsible for security. President B.J. Habibie was willing to let East Timor go peacefully, but the army was not. It defied him and the international community by organizing militia groups, with names like Red Blood, Life or Death for Integration, Thorn, Steel for the Red and White (Indonesia's flag). They had guns and the will to use them. They had drugs that they administered to whip their followers into a

killing frenzy. And they had the active backing of the Indonesian security forces that were supposed to keep the peace.

Intimidation and violence began long before the August 1990 referendum. It had no effect on Timorese people's desire to vote. Elderly Timorese women who could barely walk trudged to registration stations and again to polling booths. Young people risked their lives assisting in voter-registration drives. Those too young to vote staged rallies anyway, taking back the rights to freedom of assembly and freedom of speech that had been denied for so long. On voting day, more than 98 per cent cast their ballots. International observers from countries like Canada were stunned, and reported that they had learned a lesson about the meaning of democracy.

Almost 80 per cent of the votes were cast for independence. The freedom denied in 1975 seemed about to come true. Furious militias and Indonesian soldiers who had thought their intimidation tactics could prevent the ballot or sway the results carried out their threats, perpetrating a deliberate orgy of violence. An unknown number of people were killed. Militias acting under army direction forced hundreds of thousands of people at gunpoint to move to Indonesian West Timor. They scorched the earth. They took aim at the country's infrastructure, destroying three quarters of it. All buildings of importance were engulfed in flames. One aid worker said the country had been set back to "Year Zero," like Pol Pot's Cambodia.

There are as many horror stories as there are people about the two weeks of sustained and brutal violence in September 1999 that finally brought the world to act and send in an international peacekeeping force. Referendum observers wept as they were flown out of Dili over the fate of those they were leaving behind. A handful of UN officials refused an order to evacuate and kept up a symbolic UN presence. But there was nothing they could do. If the international community had acted sooner, on the many warnings from East Timor and from friends abroad, and sent in peacekeepers while

there was still a peace to keep, the violence of September could have been avoided. But the world had turned a deaf ear – again – and the East Timorese were paying the price – again.

In September the Laksaur militia came to Suai, accompanied by Indonesian soldiers, and began to kill people who had taken refuge in the half-built stone church of Our Lady of Fatima. They even killed the parish priest as he begged for the lives of his congregation. Father Hilário Madeira had spent time on an exchange programme in Canada just a few years before. Now he was struck down by militias, along with his assistant priests, Tarcisius Dewanto and Francisco Soares, and many others. The Canadian ambassador came to Timor, heard stories of young men being thrown into the sea to die. Violence and terror were everywhere. In almost all cases, the Indonesian army and police looked on or even took part. In Maliana, to cite only one case, protection was promised to those who sheltered in the local police station as the town was being destroyed. The militia arrived quickly and started killing people, backed by a line of armed soldiers and policemen.

Elaine met many of the widows of Maliana when she returned to East Timor in 2000. You can see them in this book, holding photos of their husbands who were killed by militias and Indonesian soldiers. No family in Maliana is untouched by this kind of loss. The widows are marked once again by tragedy, yet they keep the memory of loved ones close. Elaine was shown around the town by two boys who only agreed on the condition she show her photos overseas. Both had lost their fathers. Both spent the day chain-smoking. Why? "Missus, when I'm smoking, I don't think of my father."

East Timor is now at peace, its people building themselves a new future. Yet justice remains elusive for the widows of Maliana, for so many others who have been marked by tragedy. There has been a great deal of talk about an international tribunal on the crimes against humanity in East Timor. The result, so far, is a handful of prosecutions of

militia members. Most of the leaders in the militias and in the Indonesian army hierarchy who bear responsibility are being allowed to go free. The generals who presided over what the UN mission called "an unprovoked attack strategy"– not to mention twenty-four years of brutal and illegal occupation – have gone on to other commands or to positions as elder statesmen.

A real tribunal is still vital, for the future both of East Timor and of Indonesia's fragile democracy. It should look beyond the events of 1999, which drew world attention to the whole period of Indonesian rule, to the everyday brutality and continual human rights violations that were East Timor's lot for twenty-four years. It should look to the international power brokers who connived in genocide, to policymakers like Henry Kissinger who (newly declassified documents reveal) approved and celebrated Indonesia's invasion of East Timor.

But the world is moving in the opposite direction. Once again, it may be forgetting East Timor, forgetting the fate of a little-known people in the wake of a grand ideological crusade. An independent East Timor still needs international involvement. The work of reconstruction goes on. The countries that sold East Timor for access to the riches and cheap labour of Indonesia owe restitution to the Timorese, yet many are already turning away. Aid money is being drawn away from East Timor. As Adriano do Nascimento and Charlie Scheiner explain in their article, there is a lack of generosity in the international attitude towards the one resource that could free East Timor of aid dependence: the oil of the Timor Sea.

Nascimento and Scheiner (one Timorese, one American) are both members of La'o Hamutuk, a non-governmental organization that exemplifies on a small scale the sort of Timorese-international cooperation that the country needs on a large scale. The main work of La'o Hamutuk (Tetun for "walking together") is monitoring international agencies in East Timor in the hopes that reconstruction and "development" in East Timor will be a people-centred process. That vision is explored more fully in the essay by Inês Martins and Andrew Teixera de Sousa on building an independent East Timor.

Elaine's photos taken in 2000 show the same country she visited in 1974. The land is still startlingly beautiful, the men still treasure their pigs, families still go to market for corn and other supplies (though some of these are now ready-made instant food: one woman carries on her head not a basket but a box labelled *mi goreng*, Indonesian for fried noodles). Much, though, is different. Crosses in a graveyard on the road to Quelikai seem to go on forever. Some of the men now carry guns, like the pro-independence Falintil guerrillas photographed in their cantonment at Aileu. Young men are protesting for jobs. They can see the disparity between well-off foreigners in the administration and their own situation. East Timor has some hard choices to make about economics, about its political future, about building a new and just society, about relations with its neighbours.

This book celebrates the courage of the East Timorese, the beauty of the land and the people as recorded in Elaine Brière's photographs. It also reminds us that there is unfinished business. It pleads that the world that ignored East Timor's suffering for so many years not ignore its need for justice once again. ■

A NOTE FROM THE PUBLISHER

Praise to Elaine Brière for her passion and commitment. Working with her, and with the impressive group of writers she brought together, has been a pleasure.

Many other people have contributed to the creation of this book:

David Webster, a longtime activist and supporter of Timorese independence, generously served as collection editor. Aside from writing the introduction, he compiled the chronology. Jane Springer copy-edited nine diverse essays with aplomb. Charlie Scheiner of La'o Hamutuk co-ordinated contributions from the East Timor end, and Celine Rumalean translated from Indonesian.

David Vereschagin, the book's designer, was involved from the start. The result of his work is in your hands. Our printers – Reg Hunt and his colleagues at the University of Toronto Press – supported us at every stage.

Our gratitude goes out to the organizations and individuals who made donations to support the development and production of this book: The Public Education for Peace Society, Vancouver; The United Church of Canada, Division of World Outreach; The Canadian Catholic Organization for Development and Peace; Inter Pares; The Regina East Timor Action Network; Jim Erkiletian; Gillian Webster; and Patterson Webster.

Between the Lines is proud to be publishing this testimony about and for the people of East Timor. *A luta continua!*

Paul Eprile
Editorial Co-ordinator
Between the Lines

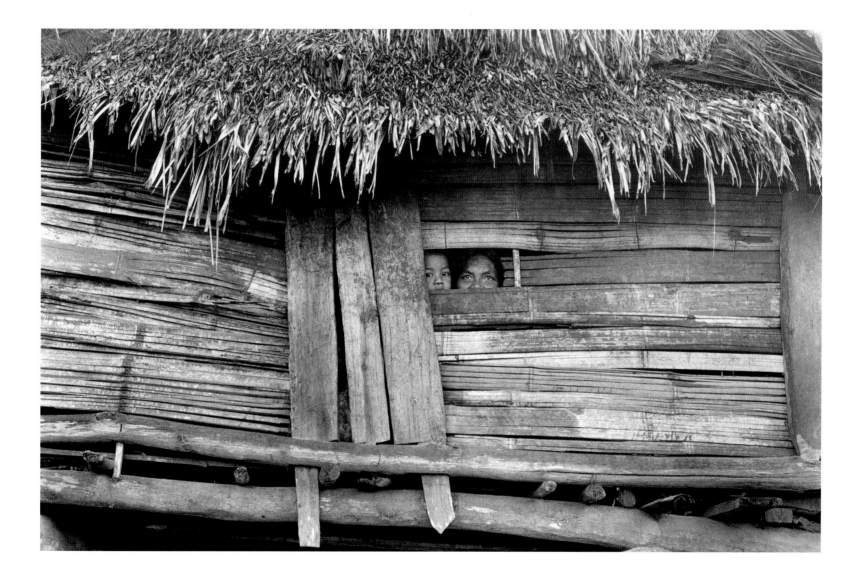

Village near Lospalos, 1974 13

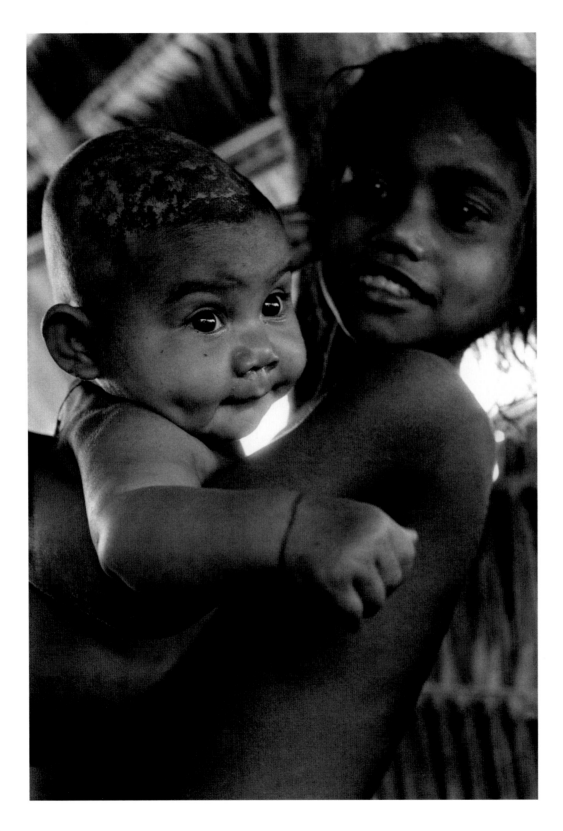

14 Seaside village, Baucau, 1974

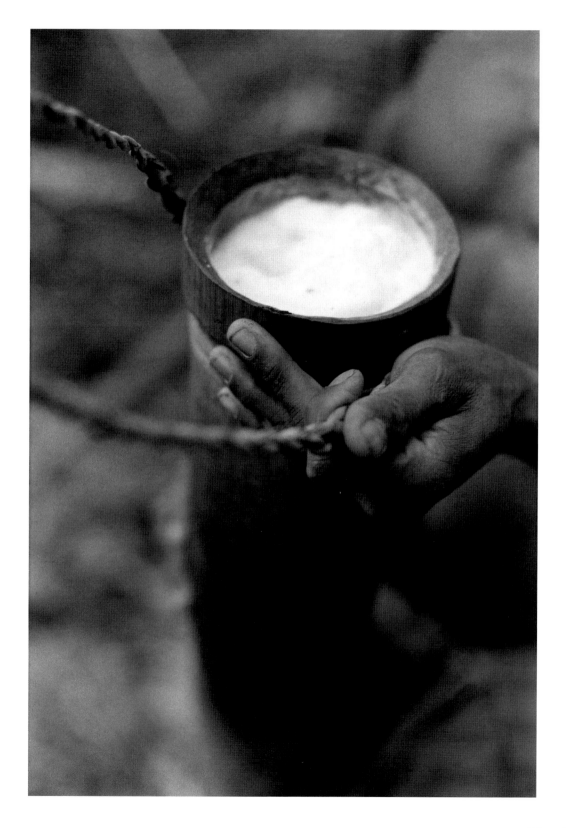

Palm wine, Baucau, 1974 15

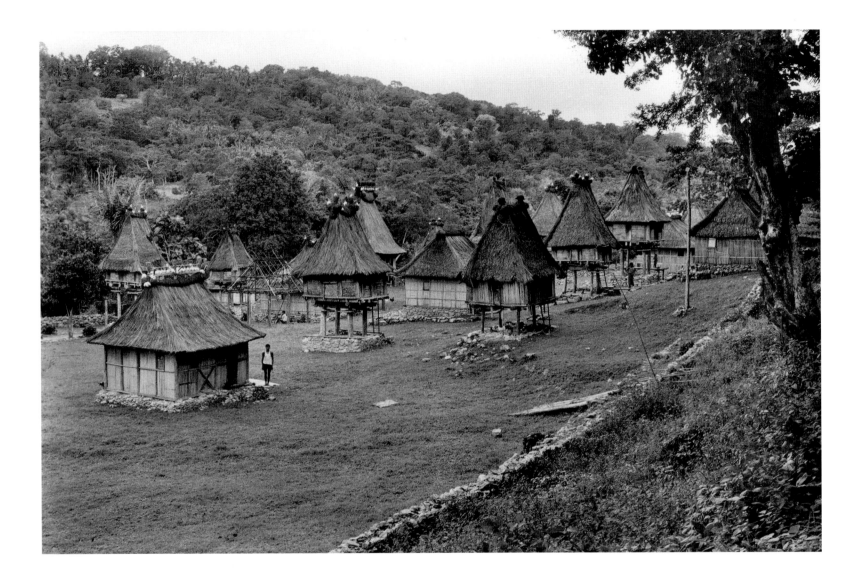

16 Village near Lospalos, 1974

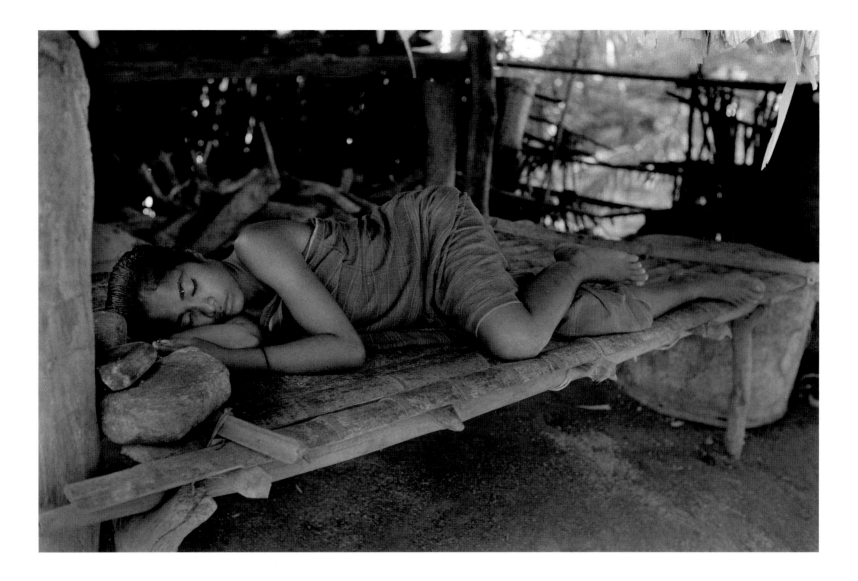

Fatima sleeping, Baucau, 1974 17

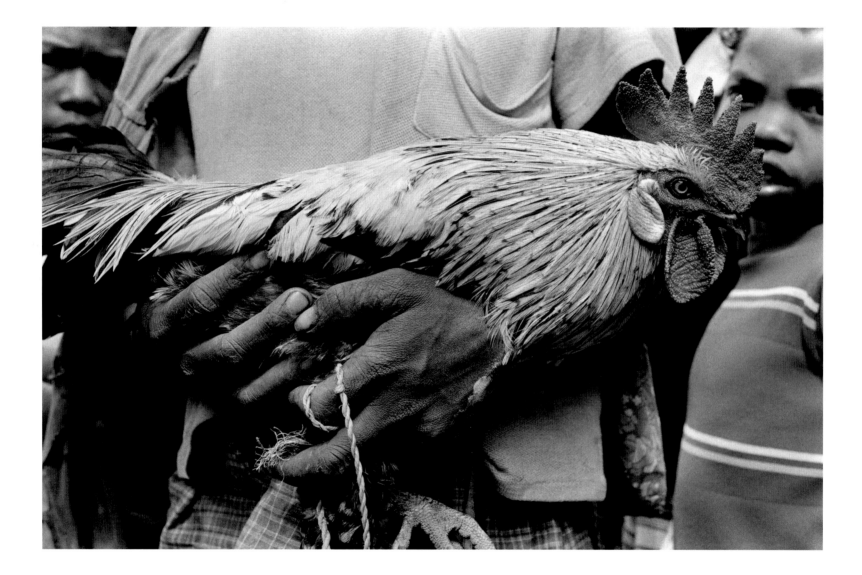

18 Man holding rooster, 1974

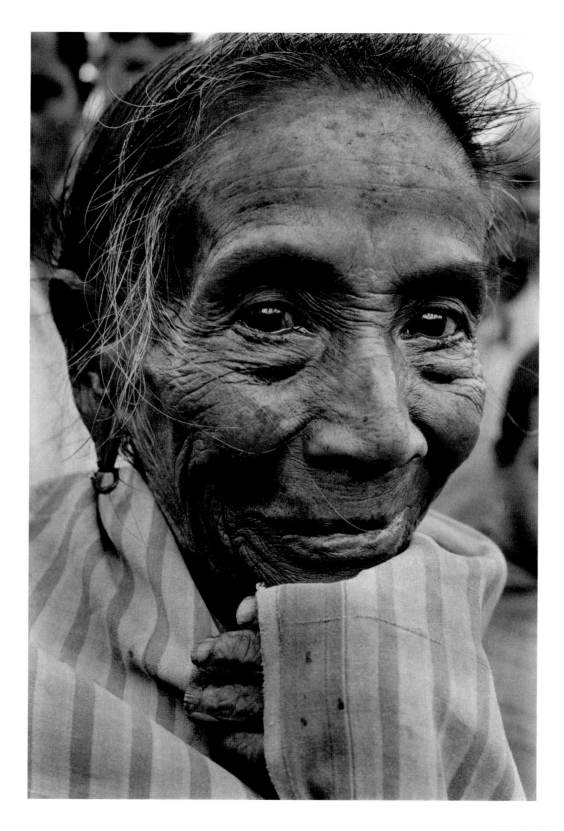

Elderly hill tribes woman, 1974 19

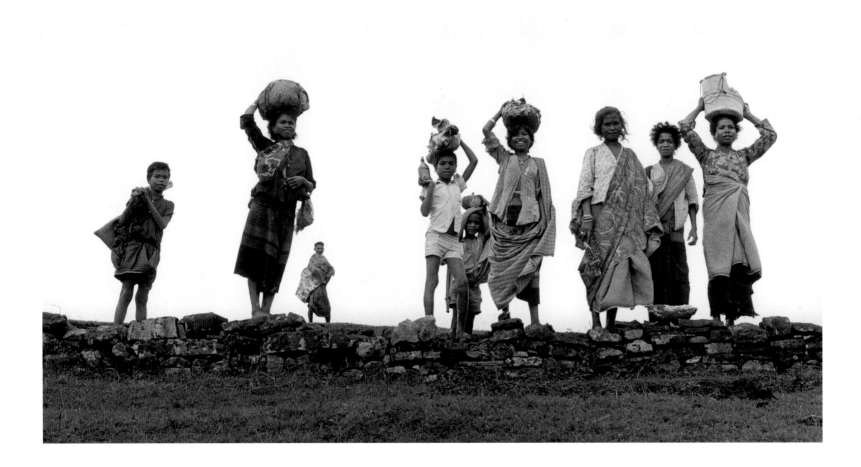

Returning home from the Sunday market, 1974

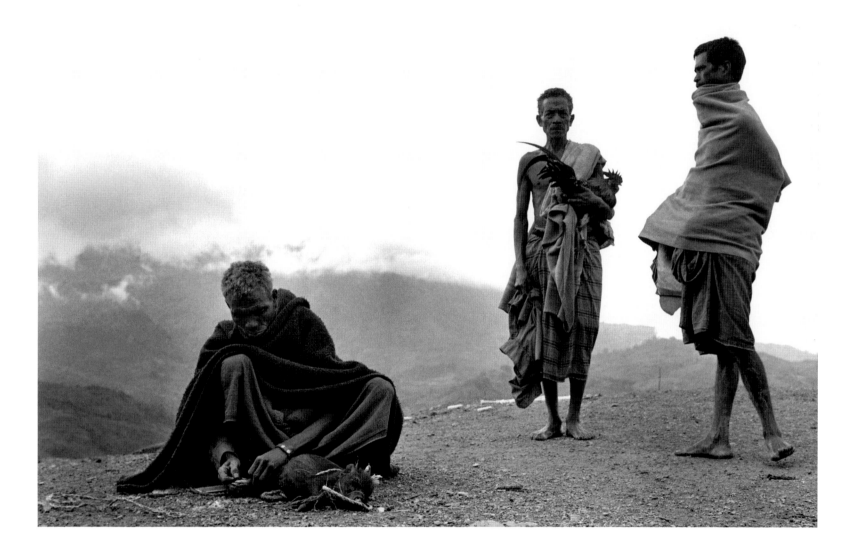

Three men, mountain pass, 1974 21

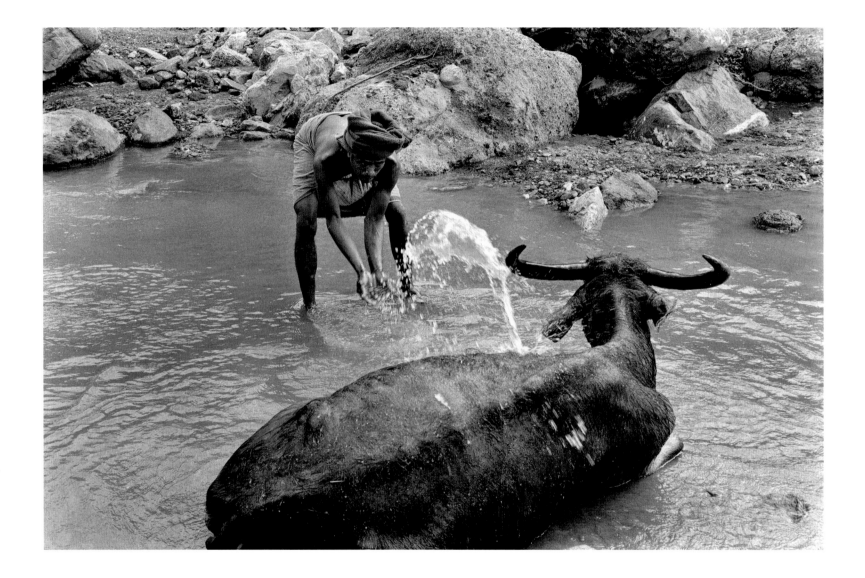

Man washing his buffalo, near Bobonaro, 1974

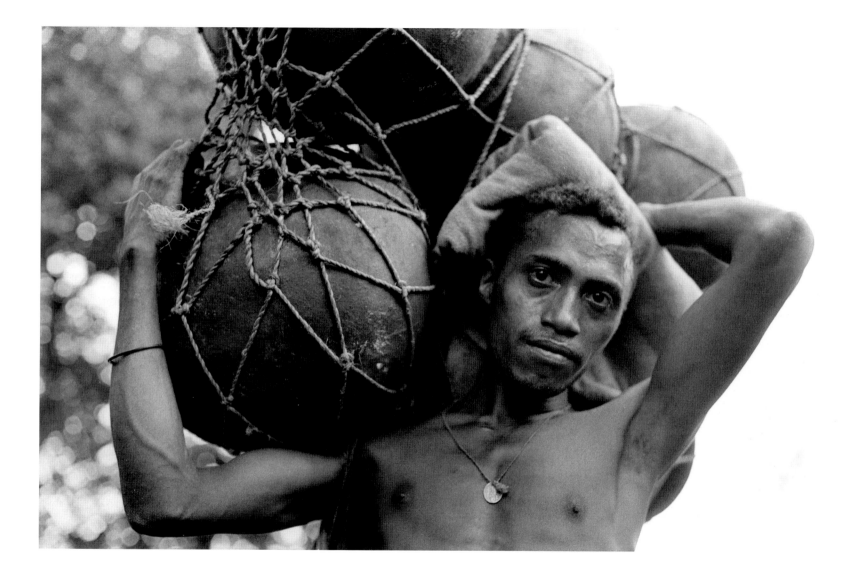

Carrying clay pots to market, 1974 23

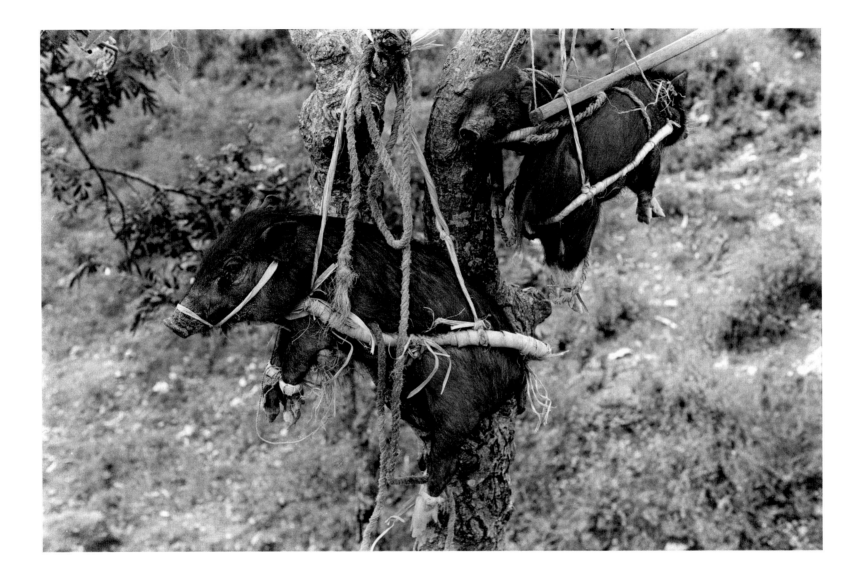

24 Pigs in a tree, Sunday market, 1974

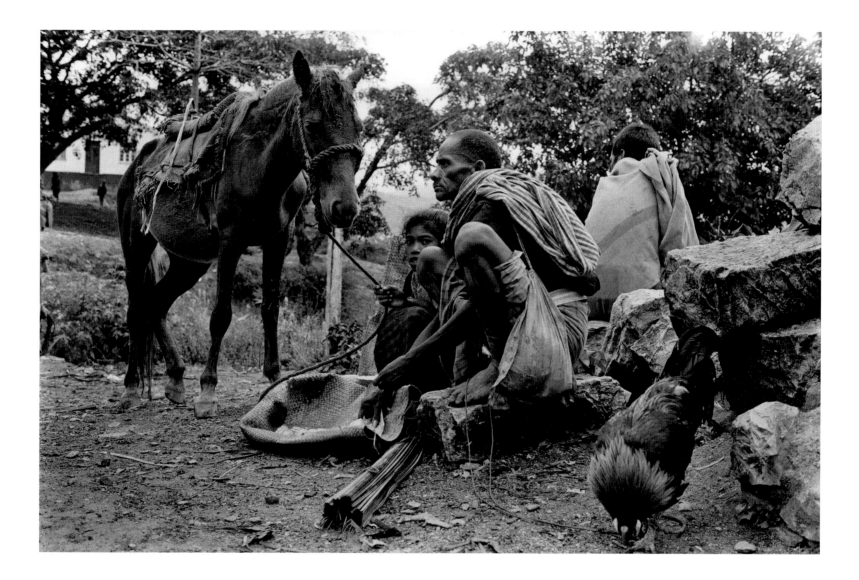

Hill tribes family, Sunday market, Balibo, 1974 25

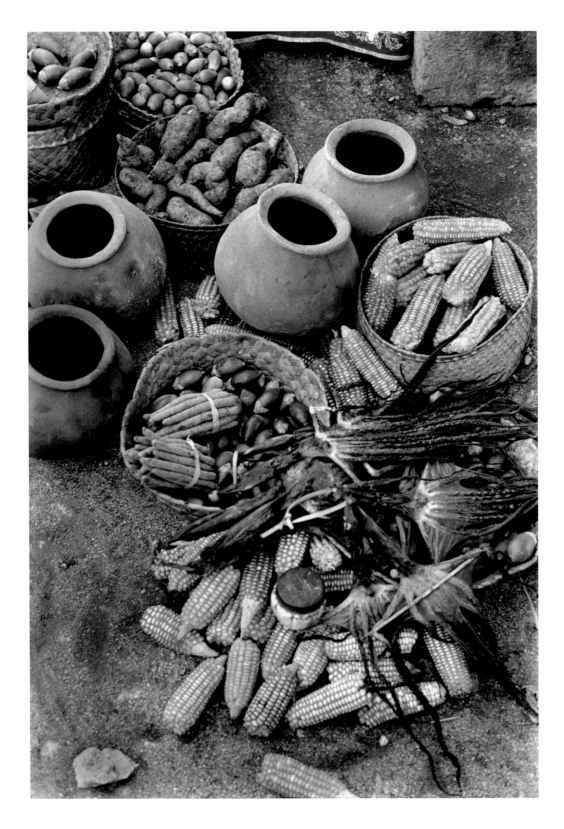

26 Sunday market, Baucau, 1974

PART 1 **RISING SUN**

MERÍCIO JUVINAL DOS REIS with
ENDAH PAKARYANINGSIH

timor,
Where the Sun Rises

Traditional beliefs have an important role in the community life of the people of Timor Lorosa'e. That is what we call East Timor – "Timor, where the sun rises." The community believes in a supreme ruler, Maromak (God) who may be contacted through ceremonies that worship the ancestors, who are believed to reside in large trees, animals, mountain tops, and thick forests. It is believed that the ancestors can protect a person wherever he or she may be. One can avoid danger by bringing to mind the ancestors' resting place. Our places of worship are houses filled with sacred objects – a sword, gold, or the tais cloth – all of which are hundreds of years old and are believed to be inherited from the ancestors.

There are taboos related to respecting the ancestral spirits. For example, eating squirrel meat is forbidden in my village, Iliomar. The story handed down by my Makalero ethnic group tells of the spirit of the ancestors being reincarnated in the squirrel, making it sacred. It is also forbidden to disturb or kill a crocodile, which is believed to be the origin of the island of Timor Lorosa'e. If disobeyed, misfortune will occur immediately.

When I was young, my grandmother told me about the close friendship between a man and a crocodile. The crocodile, which had the ability to kill a person in a single movement, once decided to help a man cross a river. Then, when the crocodile grew tired, the man attended to it and protected it until it passed away. Before dying, the crocodile instructed the man to forever live in loving-kindness with other people and other beings. After its passing, the crocodile's body turned into the island of Timor. Grandmother instructed us to protect and to take care of this land that we had inherited from the crocodile, and to live according to the crocodile's last wishes, in peace and with loving kindness.

The people of Timor Lorosa'e love their birthplace very much. By loving the land and taking care of it for the next generation, they respect their ancestors. At this time, when many people have been dispersed, the longing to return home and to visit their place of birth is still strong. When someone experiences misfortune, whether it is sickness or the failure to obtain a particular goal, their first thought is that the birthplace ancestors are angry because they have been neglected. The person then swiftly returns to his or her birthplace to ask

for forgiveness. This takes the form of traditional ceremonies that vary from region to region. After the ceremony has been carried out, the bad luck vanishes.

When the rights and self-respect of a people are trampled on, there is no option but to resist. This was the case with the people of Timor Lorosa'e, who realized that colonization and invasion were robbing them of their land and their rights. History has recorded many fights by kings of old when the Portuguese came to the island. Since 1512, about five hundred wars, big and small, have been fought against the colonizers. When the Indonesians invaded the island, it was as if darkness was forever haunting the people of Timor Lorosa'e. Again, there was suffering, suffering that was more cruel and sadistic than ever before. Many fights occurred and again, victims fell.

Our life in the village of Iliomar before the Indonesian invasion was full of tolerance. Though we had our share of arguments, we were used to helping each other in all activities, from building houses and cultivating fields to carrying out traditional ceremonies such as weddings and funerals. It was calm and peaceful.

I was a child at the time, enjoying a corn harvest. The cornfield was like a yellow carpet lying across our village. Beautiful birds took part in the celebration. They perched on tree branches at the edge of the field, waiting for the opportunity to snatch a kernel of corn. This activity was suddenly halted when a loud explosion was heard all around, accompanied by billows of smoke that made our eyes tear and breathing difficult. A few days later, many villagers were stricken with a mysterious illness. Their faces and bodies became red and swollen. A few children and the elderly could no longer walk. Many activities, including the corn harvest, ceased. Not long after, the skies above the village filled with planes and helicopters that dropped all sorts of medicine. Medics were sent to our village to help heal the mysterious sickness. The medics told the villagers that their ways were false and

forbidden. The villagers also needed the medics' medicine, which was effective in getting rid of their illness. My father said that this had happened before. He told me that in the past, after the medication drops, many traditional ways of healing had been abandoned.

I became conscious that we were not alone on our land. Shots from the direction of the mountains were heard frequently. Many people lost their children, husbands, wives, or relatives. Many of our family members got involved in discussions of guerrilla action and warfare. A few of them joined the guerrilla fighters in the forest. However, many villagers also chose what they considered to be the safest way: co-operating with the army and its programs.

I was in primary school at the time. The custom was to line up before entering class and to sing the anthem "Indonesia Raya" and pay respect to the Indonesian flag. We learned Indonesian songs and we were continually advised to remain loyal to the Indonesian Republic. One day, our school principal ordered us to gather in the schoolyard. In attendance were soldiers and officials from other schools. One of the soldiers came forward with a human head. "This is the head of a rebel we killed. Tell this to your parents and family. This will be the fate of anyone who dares fight the Indonesian State."

On another occasion, we heard that one of our family members had been caught doing clandestine activities. Soon after, the whole family was ordered to gather in a circle. We saw him in the middle of the circle with his hands tied to his back, a big hole at his feet. A few soldiers started beating and torturing him. They sliced open his chest and stomach, and took out his heart. His corpse was kicked into the hole. We were forbidden to cry.

This is only one of many similar stories that took place in Timor Lorosa'e at the time.

The occupants of a village suspected of having guerrilla ties would be moved and the village emptied. This is what happened to us. One morning, without any explanation, we were told to pack up our things and go to a place that was easily controlled and monitored by the military. They hoped to prevent us from maintaining contact with family members who were waging guerrilla warfare in the forest, to stop us smuggling food and the occasional weaponry to them. The Indonesian army also forbade villagers from meeting in a group of more than two. This dividing of family and friends made it easier for the enemy to weaken our defence and opposition. Places of worship, sacred places, and places where traditional ceremonies were carried out were burnt and destroyed.

In the new location, we worked hard to cultivate the fields to meet our daily needs. However, the Indonesian government ordered us to grow plants for export. They said that this was to improve our quality of life. The order was implemented through the wide-scale burning of forests. This of course resulted in the slow destruction of our village's ecosystem. The various plants we had used for medicine disappeared and were replaced by new plants. The animals we hunted disappeared due to the burning of their habitat. Soldiers killed many farm animals. Banana trees were chopped down on the military's order. They believed that the thick leaf clusters of the banana tree were a strategic hiding place for the guerrillas. The harvest of the export crops was not sufficient so we had to rely on selling coconuts, candlenut, and other plants for export to buy corn or rice.

Indonesian soldiers began to stake out our village limits. No one was allowed to go beyond these perimeters and if caught, a person would be shot on the spot. This isolation caused a severe shortage of food and many villagers died of starvation.

All these measures failed to paralyze our spirits. We were confident that no matter where we lived, by remembering our gods and ancestral spirits, and conducting rituals to commemorate them, catastrophe could be avoided. Although our food supply was thinning, we made every effort to stay alive. The trunk of the banana tree provided our daily sustenance. Some villagers shot birds for food. The anxiety and fear that the military had hoped to breed never materialized. This was also true for the guerrillas. Although far from the families and communities who could assist them, they were able to hold out in the forest. They managed to grow the food that they needed. The military's attempt to destroy the Makalero ethnic group failed.

The indigenous languages of the people of Timor Lorosa'e never disappeared or died. They are still in use today. Tetun is the language of the people. Portuguese is the official language, even though 70 per cent of the population do not speak it. When the Portuguese came, the Portuguese language was forced on the people. Those who were able to speak Portuguese had a higher status, which in turn resulted in inequality and was opposed by the indigenous language speakers. The Portuguese language was then re-accepted, even to the extent of becoming a symbol of resistance, when the Indonesians invaded and attempted to destroy and eliminate its use. Now only particular groups use it: elite groups in the city and a few older people. When it was made the official language, there was much opposition, especially from the young.

Most people in Timor Lorosa'e are either Catholic or Protestant. When the island was under Indonesian control, they were among the five main official religions, which include Islam, Hinduism, and Buddhism. People were required to adopt one of the religions. Religion had to be registered on

identity cards, family cards, and health cards. Indigenous belief is still rooted strongly in social life, and indigenous rituals are still conducted, especially in villages.

Timor Lorosa'e is rich in many kinds of traditional music and dance. One of the most popular dances is tebe-tebe, conducted in a big circle, with dancers holding hands and jumping forward and backward while singing songs of the struggle. The dance was often accompanied by traditional instruments such as the drum and flute. The songs reminisce about the natural beauty of Timor Lorosa'e and its kind and loving people, or tell of the people's never-ending suffering. Popular songs include O he le le, Foho Ramelau, and Kolelemai.

Indigenous concepts were vital to East Timorese survival under the occupation. The word Maubere was used as the symbol of the struggle. It originates from the Mambai ethnic group, the poorest but oldest ethnic group in Timor Lorosa'e. It is used by the Mambai people as a friendly greeting. "Mau" means man and "bere" means friend. After the arrival of the Portuguese, Maubere was used to mean "backwards" and poor. It came out of the mouths of the Portuguese rulers, elite groups with special ties to the Portuguese, and the Chinese, who were better off than the indigenous Timorese. The Portuguese colonizers also used the term for their outcasts.

Fretilin, a party formed in September 1975 as a result of the de-colonization plan of the Portuguese government, used local cultural values as a foundation of its political program and movement. Fretilin elevated Maubere to the political concept of Mauberisme. Mauberisme was vaguely defined as a group of people with honour, who farmed collectively and who shared the harvest, as well as those who chose a tribal head to make decisions. People enthusiastically greeted the Mauberisme movement, which valued their traditional culture and was fighting alongside the oppressed people. Fretilin cadres changed their Portuguese names to native Timorese names. For example, Vincent Reis became Sahe, António Carvarino became Mau Lear, and José Alexandre Gusmão became Xanana.

Now our ancestral lands and the lands of the people of Timor Lorosa'e have been returned to us. Now our people have a better chance at determining their own fate. However, there is no doubt that the Indonesian occupation has affected societal life in a myriad of ways.

Ecologically, our village of Iliomar is no longer the same. The destruction of the land through the burning of its forests has affected the soil's ability to absorb water. Now, during the monsoon, the most fertile top layer becomes eroded and gets swept away. What is left is an infertile and stony ground. In the dry season, only a few functioning natural water springs remain. Many wild animals, such as cockatoos, are diminished in number. Many have left the forests of Iliomar for more pristine surroundings. Some have been hunted for food or as show birds.

Many traditional ceremonies have changed. In weddings, money has replaced farm animals as dowry. This is because many farm animals were killed by the Indonesian military.

The Makalero language is still used in Iliomar, but not by those born after 1975 – when the Indonesian language was introduced and its use enforced. This generation has not stopped using Makalero entirely, but they do not speak it fluently. Tetun was introduced by the guerrilla and clandestine fighters during the fight against the Indonesian occupation and it was banned by the Indonesian government. Therefore, Tetun became known only to a select group of people.

Nowadays, challenges to the cultural existence of the people of Iliomar and Timor Lorosa'e continue to multiply. Some challenges may be even graver than before. The foreign influences and cultures introduced by the United Nations staffers and foreign investors have changed the landscape of Timor Lorosa'e.

If you take a walk in the town of Dili today, you will find a row of restaurants with signs for Chinese, European, and Indian food, as well as burgers and pizza – with prices far beyond what the locals can afford. Timorese food cannot compete and some shops that sell it have closed down. Luxury hotels are being built with modern Western-style architecture. Other buildings and houses are being built with fewer and fewer traditional architectural features. There are also many changes in how people dress. The use of tais and other traditional clothes can only be seen in villages. In the towns, people prefer jeans, T-shirts, and contemporary fashion.

If we recognize that all forms of repression are attempts at erasing or eroding traditional cultures, there are some important questions the people of Timor Lorosa'e must answer. Is today's situation a new form of repression? To what extent can the culture of Timor Lorosa'e continue to exist and endure? ■

CONSTÂNCIO PINTO

Elaine Brière, International Solidarity, and the Struggle for the Independence of Timor-Leste

In May 1993 after I had been touring in the United States for a month, Elaine Brière, the co-founder of the East Timor Alert Network (ETAN), invited me to Canada. She organized speaking engagements for me in Vancouver, Ottawa, Montreal, and Toronto. Elaine had been actively campaigning against her government for its complicity in the Indonesian invasion of East Timor.

What was the drive for Elaine to become involved in such a campaign? Elaine is a peace-loving woman. And because she had visited East Timor she felt close to the suffering of the people. Elaine was in East Timor a few months before Indonesia invaded. She had left only weeks before and brought with her memorable photographs, vivid representations of the island's social and cultural life. The pictures became live testimony of the people of East Timor in the ETAN campaign. One can imagine how difficult it had been to campaign with little information. Before 1989 the Indonesian army had shut down East Timor to the rest of the world. There were no means of communication, no telephone, no mail services, and no tourists. But now Elaine could speak for the people of East Timor for she possessed factual evidence of the island and

its people. In spite of many difficulties, Elaine and her friends managed to keep up their work and their spirits. They continued to lobby their government, as well as to educate the public on the untold story of East Timor. Elaine worked closely with members of the Canadian House of Commons such as Svend Robinson, and others.

In 1991 the Santa Cruz massacre boosted interest in East Timor and support for ETAN. Abé Barreto Soares and José Guterres, two East Timorese students studying in Canada, defected and sought political asylum, protesting against the Santa Cruz massacre. The increase in public attention to East Timor in Canada allowed Elaine and her friends to intensify their campaign. This time, however, her photos were not the only source of information. Also important were the images of the Santa Cruz massacre – the *Cold Blood* documentary produced by Max Stahl.

Together with Guterres and Barreto Soares, Elaine and her friends campaigned tirelessly across Canada, educating Canadians about the horror in East Timor and exerting pressure on the Canadian government to change its foreign policy. Canada had provided military equipment to Indonesia even

though the Canadian government knew that Indonesia had carried out gross human rights violations in East Timor. From 1975 to 1979 Canada abstained from all of the United Nations General Assembly resolutions on East Timor. And then from 1980 to 1982 Canada voted against all the United Nations General Assembly resolutions on East Timor.

Elaine never gave up working to support East Timor. In 1993, when I visited Canada, Elaine had a new idea of how best to present the East Timor case to the Canadian public. Her documentary film, *Bitter Paradise*, movingly reveals East Timor's historical background prior to the Indonesian invasion, as well as the aftermath of the invasion. It also highlights the complicity of the Canadian government in the invasion, and the occupation of East Timor by the Indonesian army. *Bitter Paradise* complemented other campaign tools such as Max Stahl's *Cold Blood* and Elaine's own photos.

In 1994, Elaine was not hesitant to accept my request when I asked her to support Bella Galhos, a young East Timorese whom the Indonesian government had sent to Canada on a one-year exchange program. Elaine and other Canadians organized Bella's successful escape. With Elaine's help, a few months later Bella got her landed immigrant status to temporarily reside in Canada. And so a young and energetic activist East Timorese woman began her campaign in Canada.

Elaine and all members of ETAN should feel proud of their contribution to the independence of East Timor on May 20, 2002 and the knowledge that their work was not in vain. But independence was not the end of their campaign. ETAN and many other solidarity groups around the world remain important – because a new campaign is needed for East Timor in Canada and around the world. The focus of this new campaign is to encourage governments to continue to provide economic support to East Timor. Although East Timor has achieved its independence it is still fragile. It does not yet have the strong foundation it needs to stand alone. Its infrastructure – destroyed by the Indonesian military – has not been restored, there is little formal paid employment, the rule of law is in an embryonic stage, and the justice system is weak. Schools are overcrowded, health care is not accessible to everyone, and corruption and nepotism are taking root. The international community must pay attention to East Timor in order to guarantee peace, stability, and development – indispensable elements of democracy. The success of East Timor rests in the hands of the international community, and the East Timorese, together. ∎

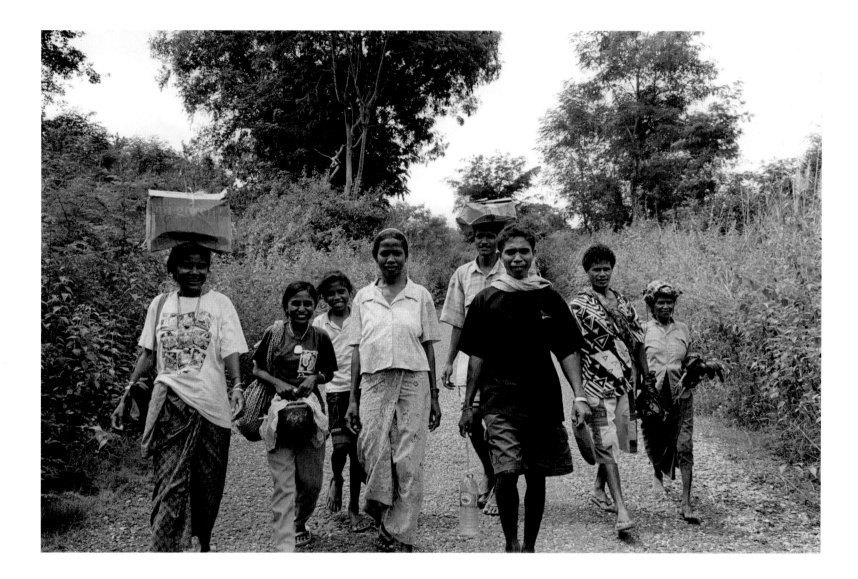

Country road near Letefoho, 2000 35

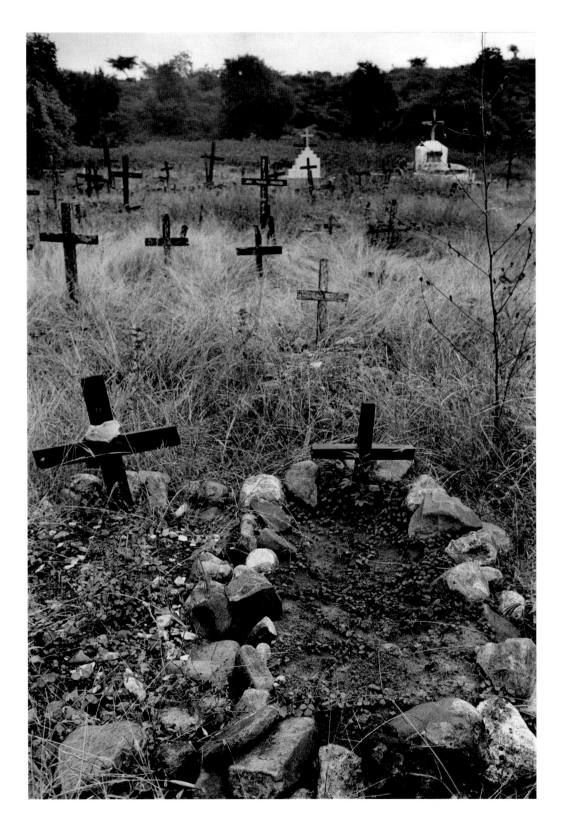

Graveyard on the road to Kelikai, 2000

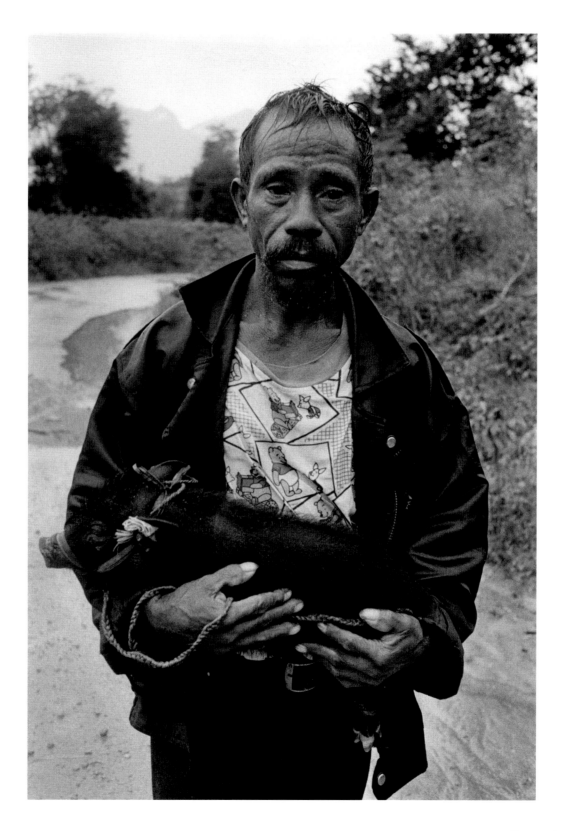

Bereaved man, Kelikai, 2000 37

38 Corn drying, 2000

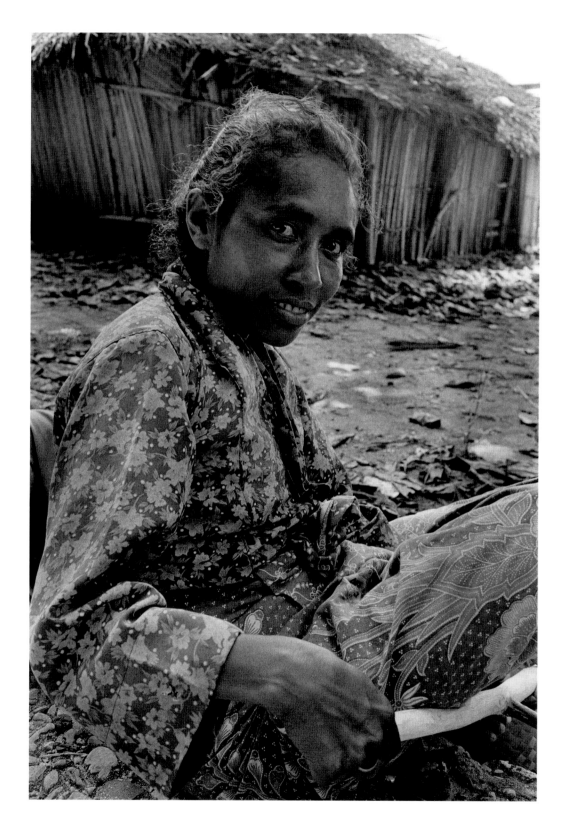

Woman working, seaside village, Baucau, 2000

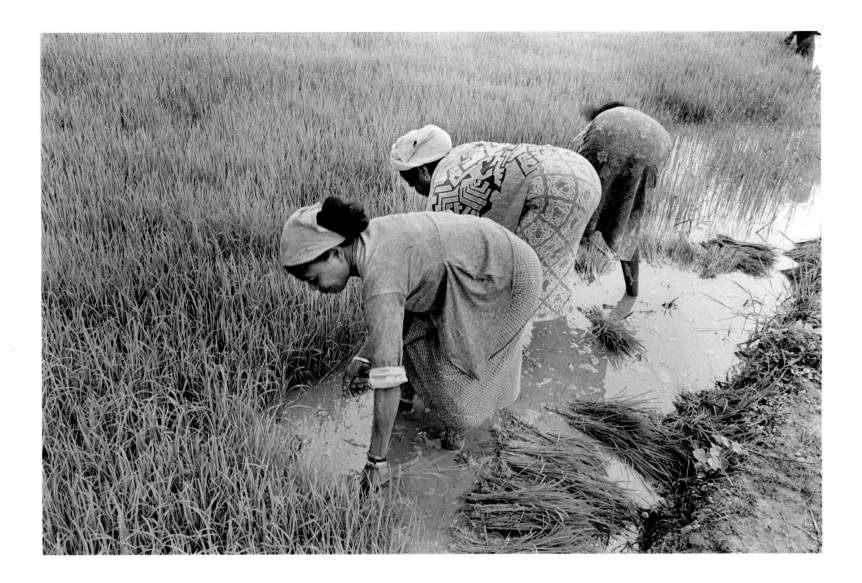

Rice harvest, Maliana, 2000

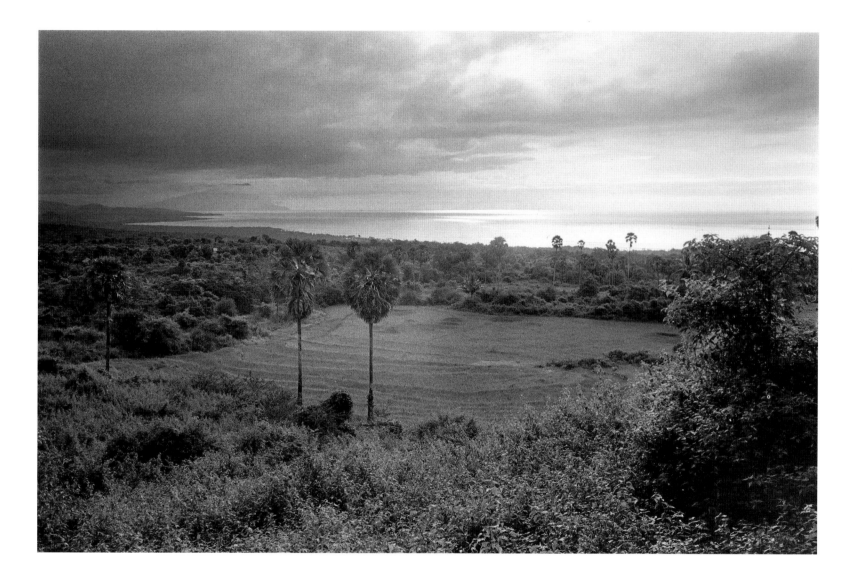

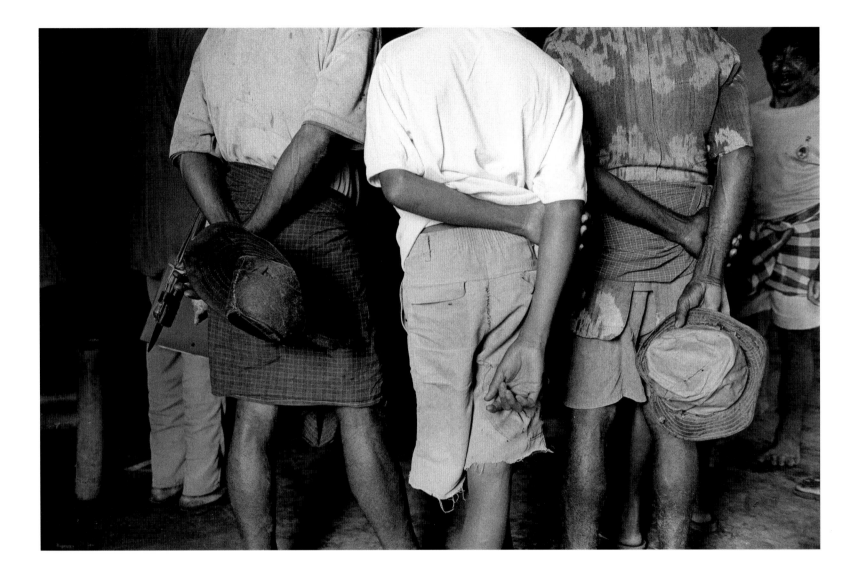

42 Village meeting, 2000

Village clerk, 2000

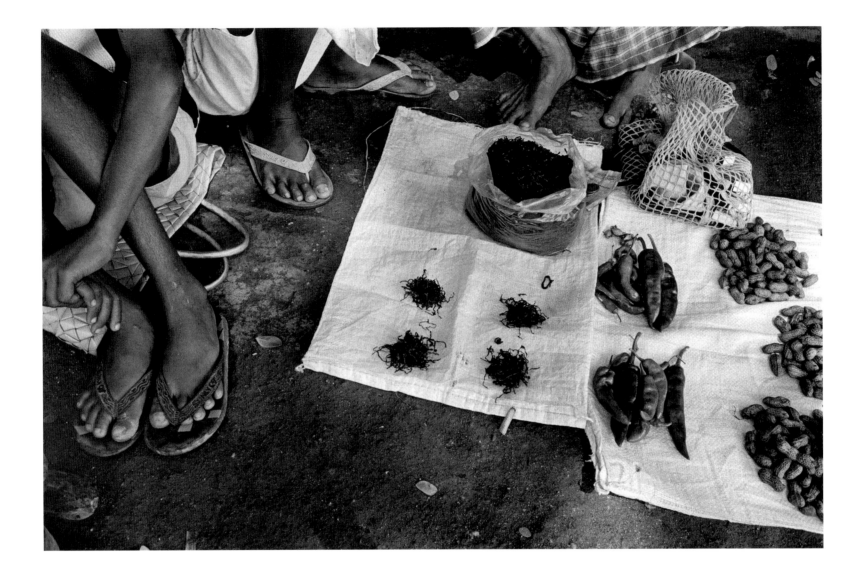

44 Tobacco, chilies, and peanuts, Baucau, 2000

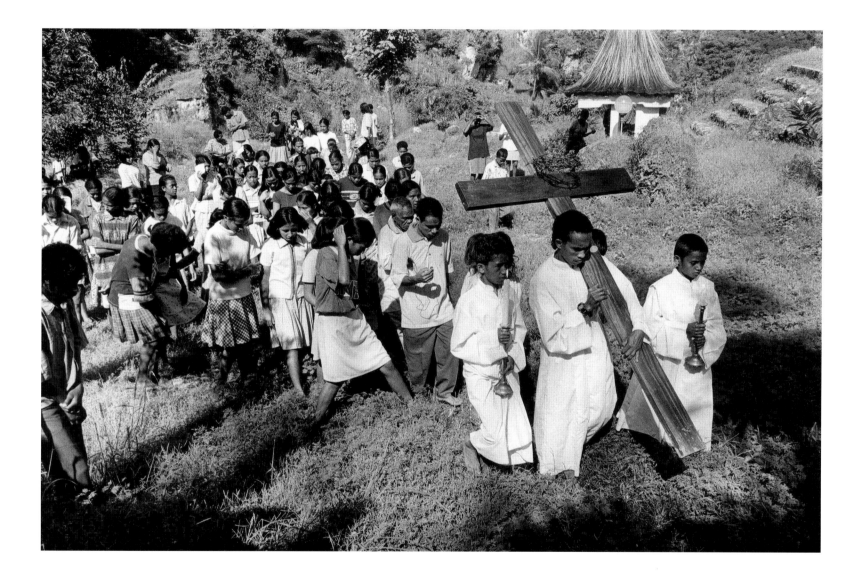

Easter Sunday, Baucau, 2000 45

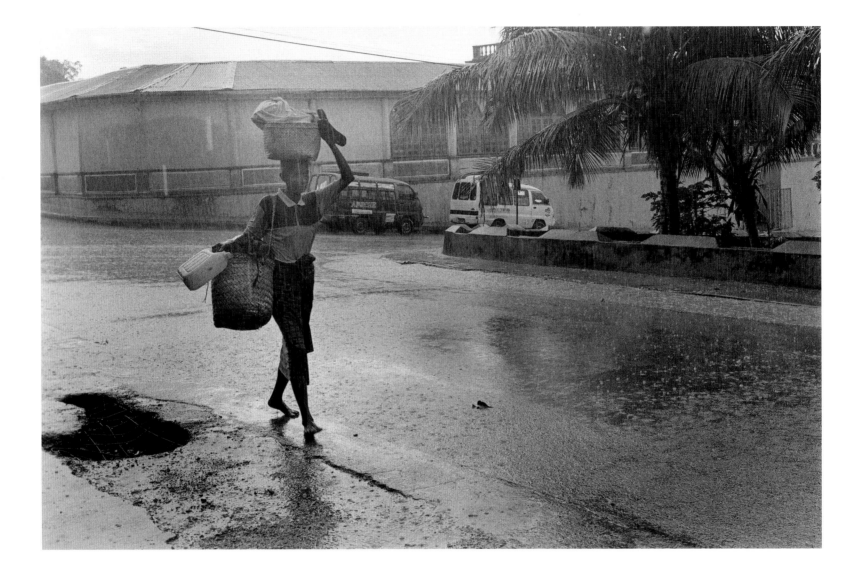

46 Downpour, Baucau, 2000

PART 2 **STORM**

NOAM CHOMSKY

Western Complicity in the Indonesian Invasion of East Timor

When the United States was planning the global order that was to take shape after World War II, it did not overlook the tiny Portuguese colony of East Timor. East Timor should receive independence, Roosevelt's senior advisor Sumner Welles commented – but "it would certainly take a thousand years." The cynicism was heightened by the wartime accomplishments of the Timorese. Ten per cent of the population lost their lives protecting a few hundred Australian commandos who remained in East Timor after the Japanese invaded. A leading Australian specialist on East Timor, James Dunn, describes this as "one of the great catastrophes of World War II." Relative to population, it is one of the most extraordinary contributions to the Allied war effort. Timorese courage and sacrifice perhaps saved Australia from invasion, with consequences that might have been severe.

The Timorese were rewarded in 1975. Indonesia's December invasion, preceded by incursions beginning in October, was anticipated by the Western powers. In August, Australian Ambassador to Jakarta Richard Woolcott advised Canberra in a secret cable that Australia should go along with the pending Indonesian invasion – because it could make a better deal for the oil reserves in the Timor Gap with Indonesia "than with Portugal or independent Portuguese Timor." Australia should take "a pragmatic rather than a principled stand," Woolcott advised, adopting the stance of "Kissingerian realism." "That is what the national interest and foreign policy is all about," he added.

Woolcott is doubtless correct about foreign policy and Kissingerian realism, and about the "national interest" as well, if we use the term in the technical sense, in which it has only an incidental relation to the interests of the nation but reflects very closely the perceived interests of domestic power. His position has a long history, as is clear from Adam Smith's critique of the "principal architects" of policy in England in his day, the "merchants and manufacturers" who made sure their own interests were "most peculiarly attended to," however "grievous" the effects on others, including the people of England. A major reason for government secrecy is the recognition that what is done in "the national interest" will not be tolerated by the population; Woolcott's "pragmatic stand" is a case in point.

Washington, not surprisingly, was also following the course of Kissingerian realism. The US Ambassador to Jakarta had informed Woolcott that he was "under instructions from Kissinger personally not to involve himself in discussions of Timor with the Indonesians." He concluded that the US should "allow events to take their course" without US involvement – except to provide Indonesia with 90 per cent of its arms, restricted by solemn agreement to defensive use.

Secretary of State Henry Kissinger and President Gerald Ford authorized the invasion in secret. A day before the invasion, Suharto asked Ford and Kissinger for "your understanding if we deem it necessary to take rapid or drastic action." Ford replied: "We will understand and will not press you on the issue. We understand the problem you have and the intentions you have."

Under the cover of an arms embargo, the United States immediately increased the flow of arms, including lethal counter-insurgency equipment. The UN Security Council condemned Indonesia's aggression and ordered it to withdraw forthwith from East Timor. The US joined formally, but that was meaningless, as UN Ambassador Daniel Patrick Moynihan explained in his memoirs a few years later. Moynihan took pride in his success, following State Department directives, to render the UN "utterly ineffective" in anything it might to do to interfere with the invasion and subsequent slaughter, of which he was quite aware. (Though surely the most important acts of his career in terms of human consequences, these are entirely omitted from the accolades to Moynihan by prominent intellectuals when he retired from the Senate in 1999. And they in no way diminished his reputation as a lone and courageous voice calling for respect for international law.)

Perhaps it is not surprising that the West should have responded in this way. Only a decade earlier, President Suharto had come to power in Indonesia in the course of a "staggering mass slaughter" (*New York Times*), which the

CIA compared to the crimes of Hitler, Stalin, and Mao. Yet the facts elicited unrestrained euphoria among elite sectors generally, including the media, along with praise for Washington for having downplayed its own role so as not to harm the "Indonesian moderates" who had taken power, opening the country to exploitation of its rich resources.

By 1978, Indonesian operations in East Timor were reaching near-genocidal levels. President Jimmy Carter stepped up the flow of arms, even using Israel to evade congressional restrictions against sending jet planes. Britain also leaped into the fray, soon becoming Indonesia's leading arms supplier. France joined as well, assuring Indonesia that it would protect it from criticism in international forums, while providing military aircraft and facilities for arms production. Others also recognized the opportunity to profit from the terror and atrocities in East Timor.

Despite limited and often deceitful reporting, the basic facts could be discovered. But they were too uninteresting to merit attention from Western elites, who were occupied with the more urgent task of professing outrage over the crimes of official enemies in post-war Indochina. The occasional departure from silent complicity in the atrocities did sometimes provoke a response: annoyance. The respected Asia specialist and foreign correspondent Stanley Karnow spoke for many when he informed a leading journalism review that he could not bring himself to read one of the rare press reports (which excluded the US role, obviously the most important information). "I just didn't have time," he explained: "it didn't have anything to do with me." What does "have to do with us" is the crimes of others, not our own – which we could mitigate or terminate by the simple act of withdrawing participation – not an uncommon feature of intellectual history.

The record is grim, therefore almost entirely suppressed, and not a likely candidate for historical memory. It teaches far

too much about the "realism" that guides policy planning, and the intellectual culture on which it relies for its achievements.

Suppression and evasion are not traceable to the remoteness of East Timor, grotesque as that excuse would be in any event. Coverage of the area was substantial prior to the Indonesian invasion, reflecting concerns in Washington about the overthrow of Portuguese fascism and the fate of its imperial possessions. As Indonesia solved the problem by invasion and massacre, attention declined, reaching virtually zero in 1978 as atrocities and the death toll peaked. In Africa, any possibility for meaningful independence in the former Portuguese colonies was undermined by South African intervention, with US-UK backing, at the cost of 1.5 million dead and over US$60 billion in damage during the years of Reaganite "constructive engagement" alone, according to a UN Interagency Task Force inquiry. In Southeast Asia, Indonesia played a similar role. In both cases, coverage and elite interest declined as atrocities increased and the threat of independence was reduced.

For East Timor, the goal of self-determination upheld by the UN (and later, the World Court) seemed hopelessly unattainable in the light of the constellation of forces: a tiny group of forgotten people confronting ruthless Indonesian violence fully backed by the reigning superpower and its allies. The means of reaching the Western public were barred through self-censorship, apart from Australia and Portugal, where there was substantial information and active popular opposition (despite Australian government efforts to keep the ugly story hidden). Australian Southeast Asia specialist Ben Kiernan, now at Yale University, reports that:

> From a small radio mounted on the back of a donkey in the rugged highlands, Fretilin's independence guerrillas broadcast rare news from the closed territory. Across the Arafura Sea, Australia's government, appeasing Jakarta,

tried to block the transmissions. Police seized the radio transceiver operated by a Timorese in Darwin. A group of Australian leftists, dock workers, Timorese and Aborigines set up a mobile transceiver. For three years they moved quietly around the outback, communicating with the resistance and publicising the tragedy. Federal Police scoured the Northern Territory but were unable to shut down the radio link.

Elsewhere too, information slowly leaked to at least parts of the public, and protest activities gained somewhat greater outreach. But despite the work of dedicated activists, most of them young, few enough to be listed easily, the impact was too slight to deter participation in another "great catastrophe," even worse than the one for which Japan was responsible. And Japan too repaid its obligations handsomely, by providing crucial diplomatic and economic support for the Indonesian aggressors.

In 1979, Australia became the only Western power to grant full recognition of Indonesia's 1976 annexation of the occupied territory. A crucial factor, presumably, was the oil interest that Woolcott had emphasized on the eve of the invasion. An Australian-Indonesian treaty to rob East Timor's oil was signed in 1989, and put into effect immediately after the 1991 Santa Cruz massacre, in which hundreds of Timorese were killed. It was the first international instrument that officially recognized Indonesia's rights in "the Indonesian Province of East Timor," offering nothing to the Timorese people, the Australian press reported bitterly.

The Santa Cruz massacre was not easy to suppress. It was filmed by a British photojournalist and broadcast in Britain, and two American journalists, Alan Nairn and Amy Goodman, were almost killed. That is not good form, and it led to the usual result when such errors are committed: an investigative commission that administered light sentences to

low-ranking officers, while absolving those responsible. It also led to congressional restrictions on US arms sales and training of Indonesian military officers, which Clinton managed to evade with some intricate manoeuvres, outraging Congress, but eliciting no other reaction.

By then, substantial solidarity groups had developed in a number of countries, and were beginning to have an influence – another reason why the Dili massacre could not simply be ignored. It is in this connection that Elaine Brière's marvelous photography, not to speak of her committed activism, had such far-reaching effects. Nothing brought home more effectively and powerfully the human dimensions of these tragedies than her photos. They are a lasting contribution, no less significant as we face the new tasks that lie ahead – and they are very serious ones.

While supervising the ongoing obliteration of East Timor, and compiling one of the worst human rights of the late twentieth century in Indonesia as well, President Suharto remained "our kind of guy," as a Clinton administration official described him in 1995, when he was welcomed to Washington. Others too praised his "benign" intent, "moderation," and general good works. So matters continued until 1998, when Suharto committed some real crimes: he began dragging his feet on harsh IMF orders, and was visibly losing control to popular pro-democracy forces. In May, US Secretary of State Madeleine Albright informed him that the time had come for "a democratic transition." A few hours later, he transferred formal authority to his hand-picked vice-president B. J. Habibie. The events were not, of course, simple cause and effect, but they symbolize the relations that prevail.

To everyone's surprise, Habibie authorized a referendum in East Timor. The army had other ideas, however. By late 1998, Australian intelligence – and surely US and British intelligence – was well aware that new Indonesian forces were landing, including US-trained Kopassus commando units

renowned for their brutality. They were also organizing local paramilitary forces ("militias") to whom they would "subcontract" the violence, in the words of Australian intelligence specialist Desmond Ball – a classic technique to seek "plausible deniability" for atrocities. The goal was to ensure that any referendum would come out "the right way."

By early 1999 serious massacres were underway, and high-ranking Indonesian military (TNI) officers made it clear that worse would come if intimidation by terror did not suffice. US-British support continued, and in the US, virtual silence. The press did not even report unanimous June 1999 US Senate resolutions calling on the Clinton administration to "intensify their efforts" (which were undetectable) "to prevail upon the Indonesian government and military" to crack down on the militias. In response to the Senate resolutions, the State Department repeated the official doctrine that "the Indonesian military has a responsibility to bring those militias under control" – the militias it was organizing and directing, as State Department intelligence was surely aware. (Reading of the foreign press would have sufficed to get the information, but in fact, extensive high-level surveillance capacities were being used.) The 1999 death toll was already in the thousands before the August 30 referendum.

Five days before the referendum, the Pentagon concluded "a US-Indonesian training exercise focused on humanitarian and disaster relief activities." The official announcement was made as the subsequent mass terror was underway, but elicited no shame or reaction, since it was (as usual) unreported.

In a display of courage that defies words, the Timorese voted overwhelmingly for independence on August 30, 1999. TNI immediately carried out its plans for virtual destruction of the territory. The US observed quietly. On September 8, after most of the country was destroyed and its population brutally expelled, Secretary of Defense William Cohen repeated the official explanation for why the US could not do anything

to stop the crimes in which it was continuing to participate. Internal security in East Timor "is the responsibility of the Government of Indonesia, and we don't want to take that responsibility away from them," he said.

"Kissingerian realism" continued to prevail. As a senior diplomat in Jakarta explained the same day, "Indonesia matters and East Timor doesn't." In official rhetoric, "we don't have a dog running in the East Timor race."

Under intensive international and domestic pressure, pragmatic calculations shifted: "we have a very big dog running down there called Australia and we have to support it," a senior government official concluded. Clinton informed the Indonesian generals that the game was over and they quickly withdrew, allowing an Australian-led UN peacekeeping force (INTERFET) to enter the territory unopposed. Until the last minute TNI commanders were declaring in the most forceful terms that they would never do so. Again, we learn a very clear lesson about where power lies, and what would have been required to terminate the quarter-century of horrors, at any point, without any intervention at all – just withdrawing crucial participation. That lesson too is unacceptable, hence suppressed. The proper story is that we "looked away," failing to intervene to stop the atrocities, and when we finally understood, carried out a noble exercise in "humanitarian intervention."

Clinton presented the approved story in his own words: "I don't believe America and any of the other countries were sufficiently sensitive in the beginning... and for a long time before 1999, going way back to the '70s, to the suffering of the people of East Timor," but "when it became obvious to me what was really going on... I tried to make sure we had the right policy." The insight came some time between September 8 and September 11, 1999, when Washington noticed a dog in the race along with other pressures: a dog that mattered, not the people of East Timor. The US "never tried to sanction or support the oppression of the East Timorese"

– while it was providing the crucial military and diplomatic support for the "oppression," continuing through the last paroxysm of fury. But we should not "look backward" Clinton announced – and for good reasons.

A bit slow on the draw, Britain continued to send Hawk jets to Indonesia several days after the landing of INTERFET, two weeks after the European Union had declared an embargo and two weeks after the Indonesian Air Force had deployed British Hawks "to anticipate any intrusion of foreign aircraft into the eastern part of Indonesian territory, especially East Timor." The author of Labour's "ethical foreign policy," Foreign Secretary Robin Cook, justified this on the grounds that the government "is committed to the maintenance of a strong defence industry, which is a strategic part of our industrial base," much as in the US.

The next "responsibility" was to ignore the bitter fate of the refugees driven to Indonesian West Timor, and to deflect the pleas of Timorese, the UN, and the peacekeeping force for dispatch of investigators to determine what had happened. The contrast with Kosovo at the same time was particularly striking. Kosovo was instantly flooded with forensic investigators to try to detect evidence of Serbian crimes after the NATO bombing. An international Tribunal for East Timor was deemed unacceptable, again unlike Kosovo. Clinton also called for reducing the very limited support for INTERFET.

The reasons for the differential response are not hard to discern. Crimes are crimes when they can be attributed to some official enemy. Otherwise they are at most errors of omission, understandable flaws in a noble record.

The victory of the people of East Timor is a stunning achievement. It is hard to think of a historical precedent. It should inspire humility, and dedication. The Timorese have enormous tasks to face: the immediate problems of survival, and of finding a way to live with one another and their

powerful and menacing neighbour, always under the shadow of the great powers.

We have tasks too, far easier ones. The first is to face the past with honesty, to place responsibility where it lies, sparing no one, no matter how close to home the arrow falls. A more urgent task is to provide massive reparations to try to compensate, at least in some small measure, for what we have done.

We should be inspired by the triumph of the Timorese to go well beyond – to look closely at the sources of the "pragmatic rather than a principled stand [that is] what the national interest and foreign policy is all about" and at the consequences, in many parts of the world, right before our eyes today. We should most definitely "look backwards," rejecting Clinton's urgings, and learn from that how to "look forward" and to act in ways that do not bring new tragedies to suffering people, but may, rather, foster and nourish their hopes for a better world. ■

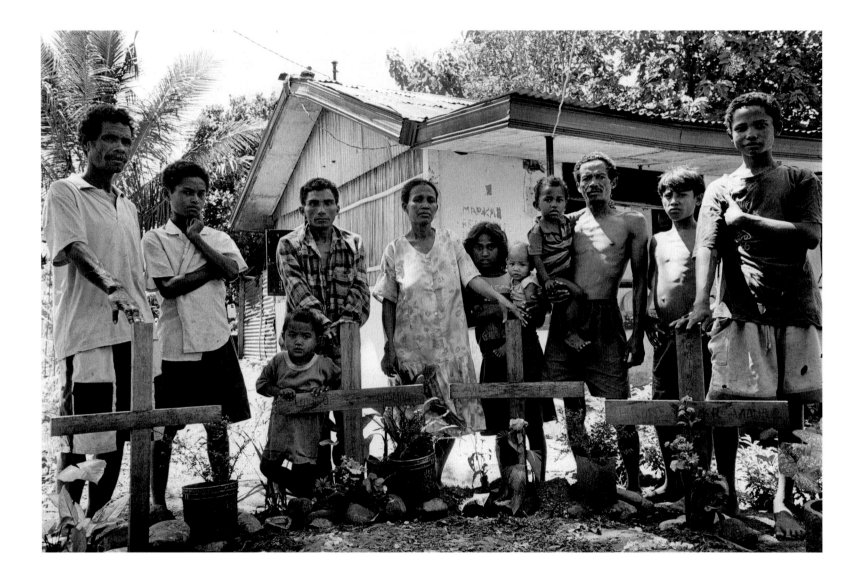

54 Relatives of four men murdered by Indonesian militia, Maliana, 2000

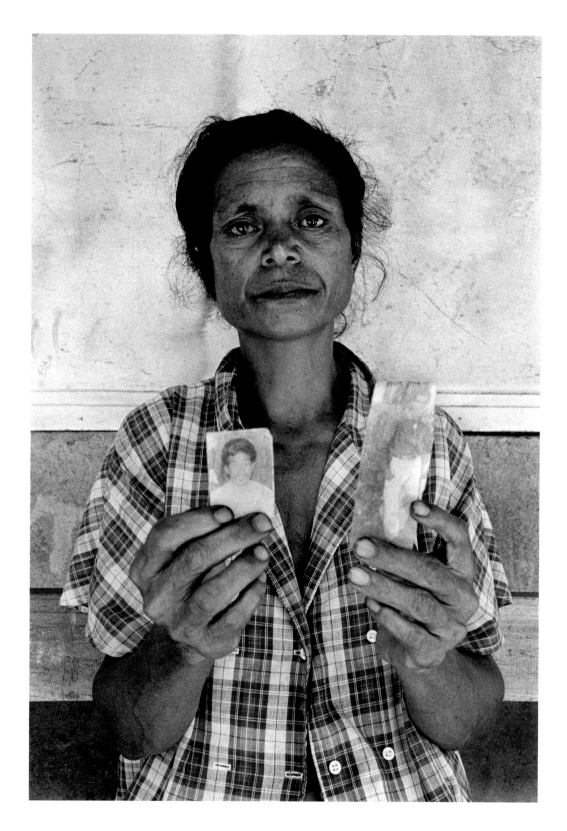

Angelina da Conceição mourning her son, Maliana, 2000 55

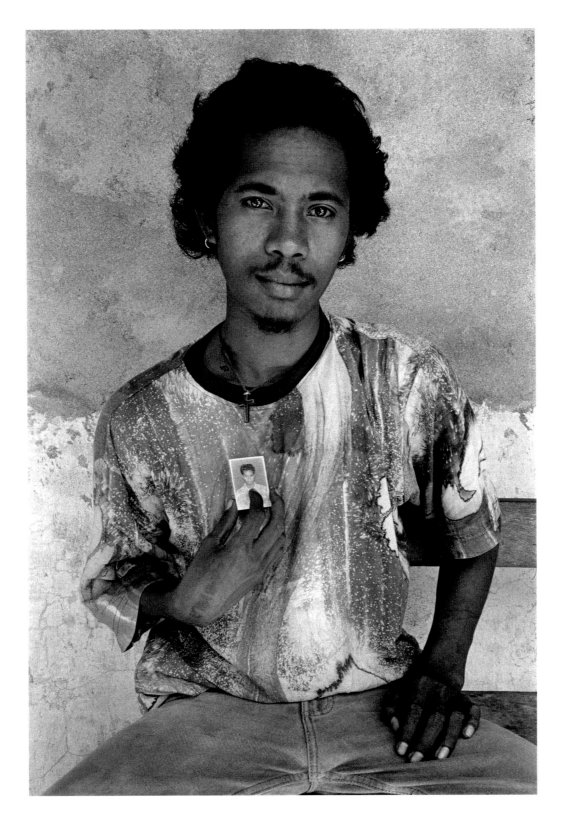

56 Manuel da Costa and his slain twin brother, Maliana, 2000

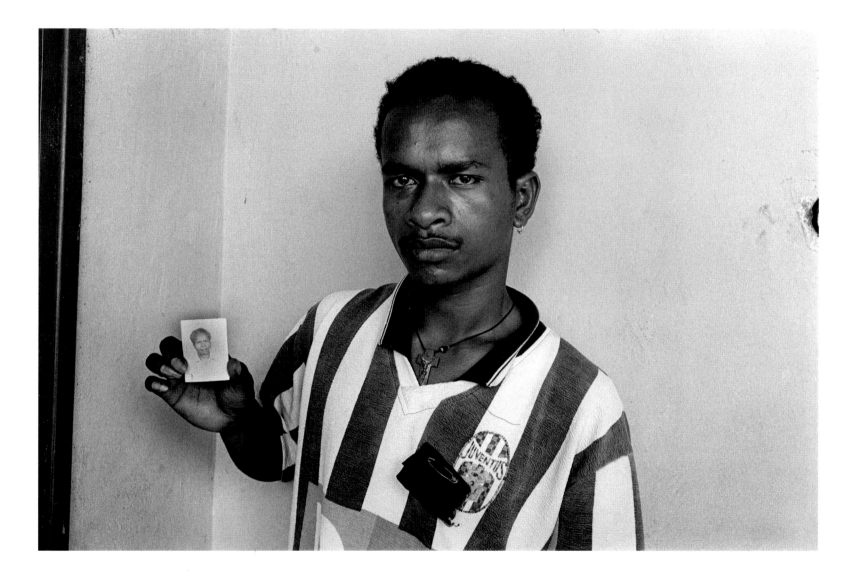

Roberto Soares Gomes and his murdered father, Maliana, 2000 57

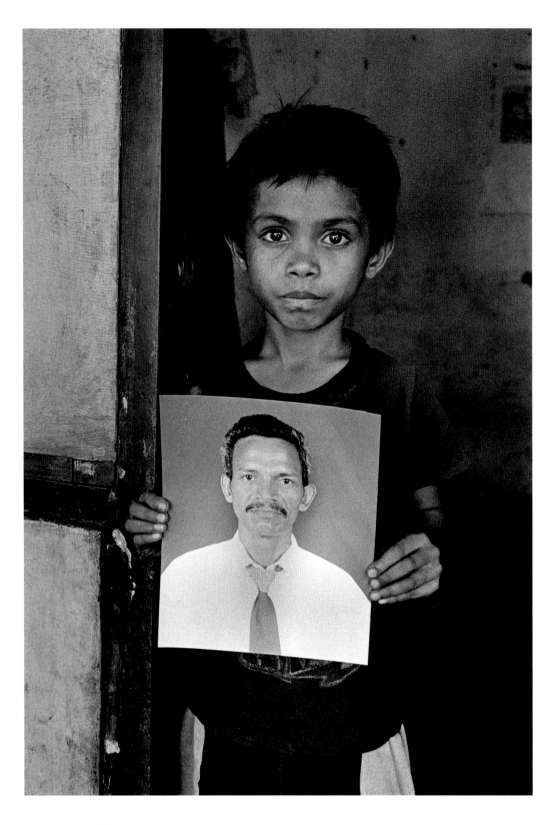

Augusto dos Santos and his father, Maliana, 2000

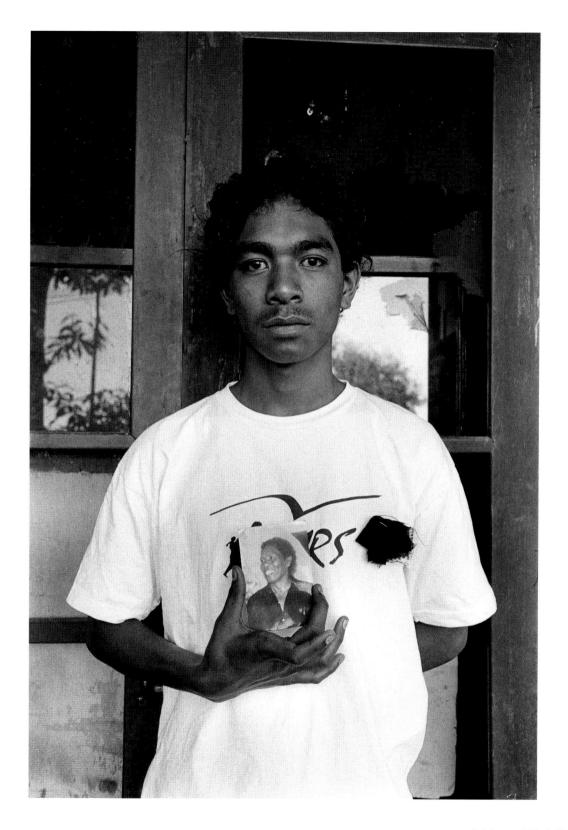

Fideles and his father, Maliana, 2000　59

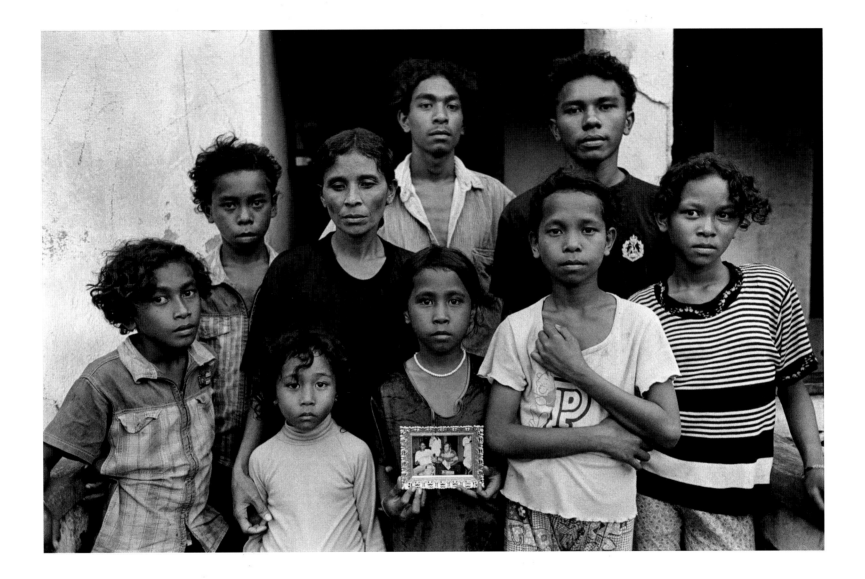

Family of murdered Manuel Magalhães de Oliveira, Maliana, 2000

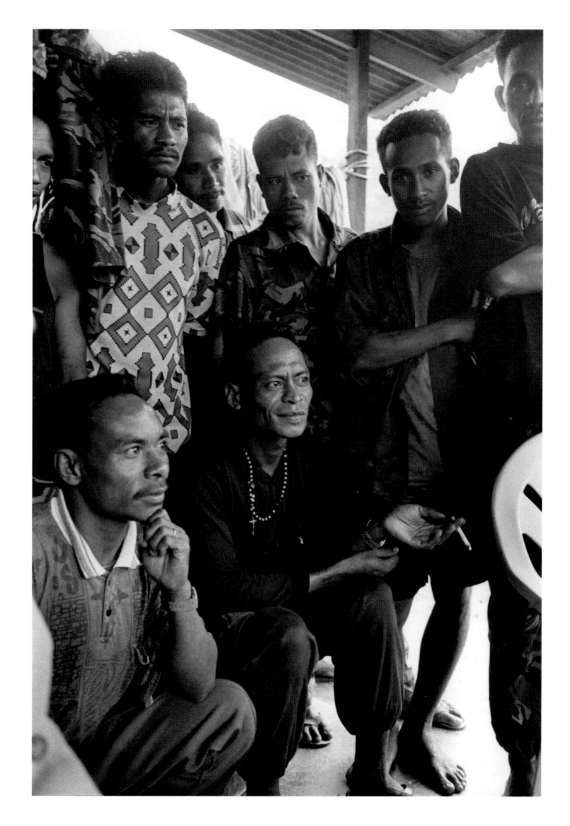

Falintil soldiers, barracks in Aileu, 2000 61

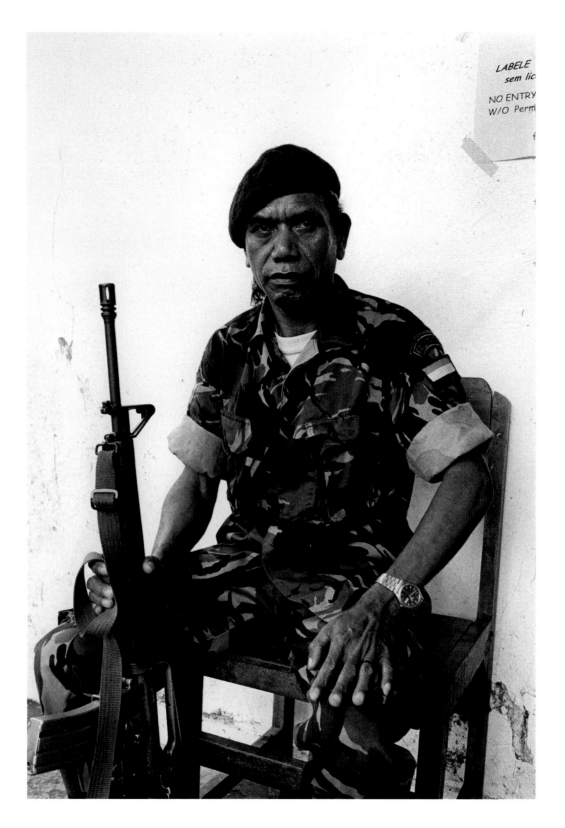

62 Commander Alende Sandi Calicus, Aileu, 2000

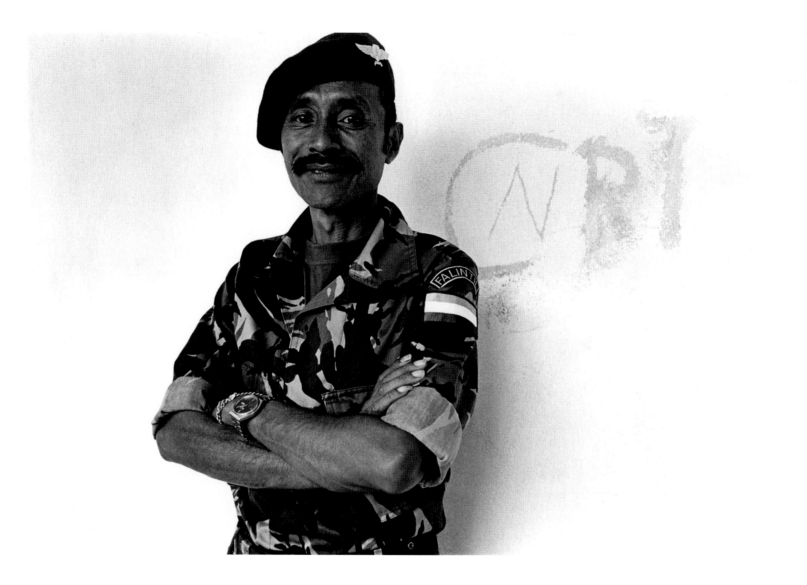

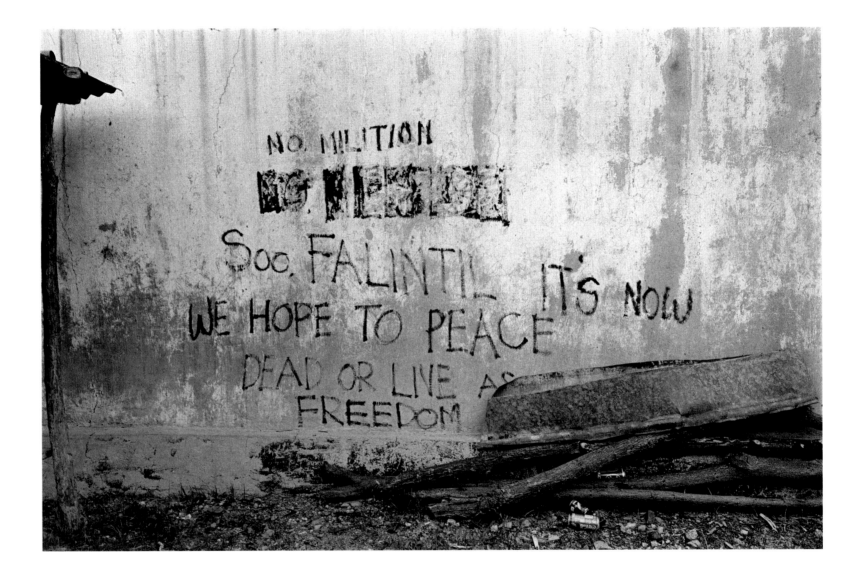

NO. MILITION

Soo, FALINTIL IT'S NOW
WE HOPE TO PEACE
DEAD OR LIVE AS
FREEDOM

64 Graffiti, Dili, 2000

CARMEL BUDIARDJO

the International Solidarity Movement for East Timor

For twenty-four years, the people of East Timor waged a bitter and at times lonely struggle against a mighty military dictatorship that enjoyed unstinting support from western governments who valued their economic ties – trade, investments, and the sale of arms – to the exclusion of all else. Indonesia's invasion in December 1975 was condemned as unlawful by the United Nations from the outset. This did not alter the reality of "business as usual" for governments, multinational corporations, and arms manufacturers.

Efforts to build international solidarity with East Timor were confronted by a powerful pro-Suharto lobby whose supporters closed their eyes to the unprecedented brutality of the Indonesian occupation, starting from the day of the invasion on December 7, 1975. Another barrier came from people on the left who believed that the East Timorese should throw in their lot with the Indonesian people's fight for democracy, on the assumption that the fight for independence was a lost cause. In Indonesia itself, the distortions disseminated by the regime, and lack of information, held back solidarity for many years.

It was against this that the international solidarity movement – which went through several distinct phases – was built.

During the first years of occupation, when Fretilin, the Revolutionary Front for an Independent East Timor, was still in control of much of the territory, many solidarity organizations in Europe and Australia campaigned on the issue of independence for East Timor and support for Fretilin. This was particularly true of the Campaign for an Independent East Timor in Australia, led by Denis Freney. A man deeply committed to East Timor, Freney was able to maintain regular radio communication with the movement inside and to produce a constant flow of reports and newsletters that generated support around the world.

The Australia East Timor Association also came into existence in 1975 and kept up relentless pressure on succeeding Australian governments. However, by 1979, Fretilin had suffered heavy defeat and for a time seemed to have all but disappeared. The flow of radio information was halted in 1977 and solidarity groups were bereft of information. This was the bleakest period for East Timor internationally and, with the

prospect of independence very remote, solidarity organizations focused on independence waned.

During this period the strongest solidarity came from East Timor's fellow ex-Portuguese colonies, countries like Mozambique, which provided places of exile and concrete support despite their own difficulties. José Ramos Horta paid tribute to these countries when he was awarded the Nobel Peace Prize, saying, "You have been with us in our most lonely years when the rest of the world pretended we did not exist or offered us advice on how best to surrender."

For the next few years, several Catholic groups and individuals in Australia played a critically important role by making contact with East Timorese who were stranded in Indonesia or who could be contacted in the territory. They succeeded in gathering information about the terrible sufferings of the East Timorese, many of whom had been corralled into strategic centres under tight military control.

In this phase, the emphasis was on human rights and the humanitarian tragedy unfolding in East Timor. For several years, the onus was on human rights organizations like TAPOL, the Indonesia Human Rights Campaign, to keep the issue of East Timor alive. In 1982, the Australian Senate conducted an inquiry into conditions in East Timor at which TAPOL was one of many groups who testified.

In July 1981 the People's Permanent Tribunal held a tribunal in Lisbon before a panel of well-known jurists, at which the Fretilin central committee made an indictment against Indonesia for its unlawful occupation of East Timor and for the crime of genocide. The US government was also indicted for supporting the Indonesian aggression. The Portuguese solidarity organization, the CDPM (Comissão para os Direitos do Povo Maubere, Commission for the Rights of the Maubere People), was born at this time and led for many years by Luisa Pereira.

Support was building for representations to be made at the UN's Decolonization Committee, whose agenda included East Timor, despite intense lobbying by Jakarta. One of the first people to testify there, in 1978, was Noam Chomsky, the political analyst and linguist who has retained an abiding interest in East Timor and the US role in supporting the invasion. Attendance by activists from all over the world on East Timor's behalf became a regular feature of the committee's meetings throughout the 1980s and 1990s.

Gradually, the issue of East Timor was brought to the attention of the US Congress which, as early as 1980, sent letters to the US administration on a variety of issues, thanks to persistent lobbying by Arnold Kohen.

In the United Kingdom, Lord Avebury, who had condemned the invasion from the start, pushed for a debate in the House of Lords in December 1980. Avebury asked the House of Lords to condemn the Australian government for issuing an injunction against the *New Statesman* for an article demonstrating the British ambassador's secret support for the Indonesian invasion in 1975. The all-party Parliamentary Human Rights Group, of which Avebury was chair, called repeatedly for an arms embargo against Indonesia because of its occupation of East Timor.

The Washington lobbying paid off when US President Ronald Reagan's visit to Indonesia in 1986 was plagued with negative media coverage, even leading to several well-known journalists being refused permission to enter Indonesia to cover the visit.

Throughout the whole period, Amnesty International made regular interventions and issued reports on the human rights situation in East Timor. In 1983, the organization published an official Indonesian torture document that had been smuggled out of Indonesia by the late Martinho da Costa Lopes, following his removal as the bishop of Dili.

In the UK, support passed through several phases. In the early years, the British Campaign for an Independent East Timor (BCIET), spearheaded the movement, with TAPOL closely involved but also conducting its own activities and information gathering. After BCIET became defunct in 1979, TAPOL kept the issue alive.

In 1984, the British government concluded its first contract to sell Hawk aircraft to Indonesia. This led to a fruitful partnership between organizations in solidarity with East Timor and the Campaign Against Arms Trade. During the early 1980s, church-based organizations – especially the Catholic Institute for International Relations, and the Catholic Agency for Overseas Development – took up the campaign with vigour. The British Coalition for East Timor drew together all these NGOs and a number of peace groups. The coalition grew in strength, especially after launching a campaign for support following the Santa Cruz massacre in November 1991.

This was the phase of building an international solidarity network and strengthening support for East Timor among parliamentarians. From the early 1980s, as contact with the East Timorese resistance and its leader Xanana Gusmão was gradually re-established, solidarity organizations were formed in many European countries. The organizations held annual consultations, taking turns to host the gathering. Now the issue was the need for peace talks under the aegis of the UN, and when the level of fighting grew intense, for a ceasefire, and exposing the consistent pattern of human rights violations. Although this was primarily a European network, the Free East Timor Japan Coalition also began to attend meetings.

In November 1987, the international solidarity movement spread its wings to the whole of the Pacific with the holding of the first Asia-Pacific Consultation on East Timor or APCET, in Manila, and later, solidarity groups held gatherings in ASEAN capitals, often in the face of police clampdowns. The ASEAN governments were under strong pressure from "big brother" Indonesia to allow no space in their countries for gatherings to support East Timor.

In June 1988, a UK-Japanese parliamentarian mission visited Portugal for meetings with Portuguese MPs, which led to the establishment of Parliamentarians for East Timor (PET), chaired by Lord Avebury. PET undertook a number of international actions, including making representations to the UN Secretary-General about the fate of East Timor. The European Parliament adopted several resolutions throughout the 1980s and 1990s. In March 1989, a group of British MPs made a visit to East Timor. One member of the group was MP Ann Clwyd, who from then on committed herself to supporting East Timor.

In Canada, a solidarity group called East Timor Alert Network (ETAN) was set up in 1986 on the initiative of Elaine Brière, whose stunning photographs of the villagers she met, and the villages she stayed in, are the backbone of this book. Brière's photographs were used extensively by solidarity groups in their publications.

In 1991, a Portuguese parliamentary delegation was scheduled to visit East Timor. The trip was called off at the last minute, amidst bitter acrimony between the Indonesian and Portuguese governments. Indonesia tried to exclude journalists critical of its occupation of East Timor and Portugal cancelled the trip in protest. In East Timor, this led to a highly volatile atmosphere, which exploded into a huge demonstration at the funeral of a murdered independence activist on November 12, 1991.

The Santa Cruz massacre left nearly three hundred young people dead, but the presence of foreign journalists garnered world attention when the footage of the massacre at the cemetery taken by Max Stahl was shown on television screens worldwide. For the first time, Indonesian brutalities were made visible and stirred an unprecedented level of anger. This inspired the birth of the East Timor Action Network, a solidarity organization in the US.

The film, *Cold Blood*, broadcast by Yorkshire Television in January 1992 using Stahl's dramatic footage, inspired Irish activists to create the East Timor Ireland Solidarity Campaign. It became one of the most effective solidarity groups, under Tom Hyland, soon to become a household name in the Republic of Ireland.

Following the Santa Cruz tragedy, the international solidarity movement entered a new phase. Not only was Stahl's footage reverberating round the world, but US journalists Alan Nairn and Amy Goodman, who were present at the massacre and had almost been killed, spared no effort to campaign in Washington and throughout the US. Their actions helped to build a powerful network of ETAN local groups that became one of the most effective Washington-oriented lobbies in the country. Early in 1994, John Pilger's film, *Death of a Nation*, generated huge interest in East Timor in the UK and elsewhere.

In the UK, the issue that most successfully won nationwide sympathy for East Timor was the campaign calling for an arms embargo against Indonesia. The UK had become Suharto's most faithful arms supplier after the US. Central to the campaign was the sale of Hawk aircraft, dating back to April 1984, when TAPOL first raised the issue. The Campaign Against Arms Trade, with its well-organized national network, was a consistent partner in this campaign.

In January 1996, three women, Andrea Needham, Lotta Kronlid, and Joanna Wilson, supported by Angie Zelter, the fourth member of the team, entered a British Aerospace military site armed with hammers and disarmed a Hawk jet being readied for Indonesia. Making no secret of their action, they informed the company and were promptly arrested. Their trial in July 1996 made legal history: they were acquitted by a jury in Liverpool who found that they had acted in order to prevent the greater crime of genocide. The acquittal made headline news and attracted intense public debate and attention in the UK, elevating the arms embargo issue to a new

level, while keeping the situation in East Timor permanently in the foreground.

In 1994, the Asia Pacific Coalition for East Timor (APCET) was formed in Manila, creating for the first time grassroots support for East Timor within Asia. APCET held its second gathering in Kuala Lumpur in February 1995. It was attended by groups from nine countries, including two Indonesian organizations that pledged to make East Timor a major part of their campaigning in Indonesia. Not long after, Solidarity Action for East Timor (Solidamor) was set up in Jakarta to campaign exclusively on East Timor.

The third APCET meeting was held in March 1998 in Bangkok, the authorities there doing everything possible to force all the foreigners to leave and disrupt the proceedings. A decision was taken to hold the next APCET conference in Jakarta but by the time the event was convened at the end of 2000, the situation had changed dramatically. The UN was now in control of East Timor and the people had voted decisively for independence from Indonesia, so APCET held its next conference in Baucau.

Several years earlier, parliamentarians from thirty-two countries had met in Lisbon in May-June 1995 and drawn up a plan for a number of parliamentarian visits to Indonesia and East Timor. Its communiqué called on Indonesia to abide by the UN resolutions on East Timor and urged all countries to stop selling arms to Indonesia.

Shortly afterwards, a conference on Indonesia and Regional Conflict Resolution, in Darwin, was attended by many delegates from Indonesia, reflecting the fact that East Timor was now an important issue for Indonesian NGOs. Another conference at the Australian National University in Canberra on Peacemaking Initiatives in East Timor in July 1995 attracted academics, human rights and peace activists as well as Indonesians and East Timorese informal leaders from inside

the country. These events demonstrated the breadth of interest in Australia on the issue of East Timor.

In November 1997, when the Suharto regime had been hit by the Asian financial crisis, many heads of state attended the Asia Pacific Economic Co-operation (APEC) summit in Vancouver. For ten days prior to the event, thirteen exiled East Timorese and several Indonesians toured Canada, calling on the authorities to "bar Suharto or put him behind bars" for the atrocities for which he was responsible. Several thousand people, many attending a People's Summit, gathered to protest the presence of Suharto in Vancouver. Activists held a "people's tribunal" to try Suharto and then attempted to present citizens' arrest warrants to the dictator before they were arrested by Canadian police.

Realizing the strength of concern in Canada about East Timor, the Indonesian dictator had insisted on firm guarantees from the Canadian government before agreeing to attend the APEC summit. This was provided by mounted police who used pepper spray on the crowd – causing mayhem – and who arrested forty protesters.

Another important part of the solidarity movement was a series of seminars, most of which were held in Portugal throughout the 1990s, bringing together academics and activists from Indonesia and around the world. The initiative for these events was taken by Professor António Barbedo de Magalhães, whose acquaintance with East Timor went back many years. These meetings encouraged discussion with many mainstream Indonesian academics who were under pressure in Indonesia to keep a distance from the question of East Timor.

The international solidarity movement with East Timor became very well organized over the years and contributed massively to informing public opinion and forcing governments and institutions to acknowledge the injustice and brutality of Indonesia's invasion and occupation. It was a loosely organized movement, including a wide variety of groups and individuals. The International Federation for East Timor listed solidarity groups in thirty-one countries. But its persistence meant that governments were not able to ignore the legitimate demands of the people of East Timor.

After a referendum conducted by the UN in August 1999, when 78 per cent voted in favour of independence, the East Timorese began the final lap of their journey to create an independent state. After two years under UN administration, the Democratic Republic of East Timor was reborn on May 20, 2002 and proudly took its seat in the UN, the first new state of the twenty-first century.

Investigations into crimes against humanity and war crimes committed around the 1999 referendum were conducted by the UN and by an Indonesian investigation commission, resulting in calls for those responsible to be brought to trial. Both commissions called for the establishment of an international tribunal, but the UN has yet to act on this.

Under pressure from the international community and in an effort to forestall the creation of an international tribunal, Indonesia set up an ad hoc court for East Timor. However, it had a mandate to try cases of crimes committed only in April and September 1999 and in three East Timorese towns. Only eighteen suspects were indicted, excluding some of the most senior Indonesian military who had been named by the Indonesian investigation commission. Twelve of these eighteen were found "not guilty." Of the other six, all but one received less than the minimum sentence required by Indonesian law. All those convicted of crimes against humanity remain free on appeal. And the worst violators, those indicted by the joint UN-East Timor Serious Crimes Unit, are getting away scot-free. Of the 367 people indicted by the serious crimes unit, 280 are in Indonesia, which has refused to extradite them.

These results have been condemned by the international soldarity movement, which has repeatedly called for implementation of the UN International Commission of Inquiry on East Timor's recommendation for a truly international tribunal.

Inspired by the determination of the East Timorese to resist military occupation, the solidarity movement achieved remarkable success. The East Timorese people freed themselves, but solidarity activists played an important role in helping sway international public opinion.

Although East Timor has won its fight for independence, there remains a great deal of work to be done. The tribunals in place fall far short of what is needed. Stability, peace, and reconciliation cannot be achieved without justice. Yet East Timor cannot deliver justice on its own. Its efforts must be fully supported by the international community.

East Timor is confronted with the daunting problems of reconstructing a battered infrastructure, restoring its economy, ensuring respect for human rights and the rule of law, and improving the health and welfare of the people. Its people will grapple with these problems with that tenacity and sense of purpose that were so clearly demonstrated throughout the occupation, but they continue to need international solidarity. Yet aid dollars are already leaving, heading for countries that will spend them on a "war against terror." And the oil resources that might help ensure stable revenues are being stolen by Australia.

Meanwhile, the struggle for human rights and true democracy in Indonesia continues. The Indonesian armed forces, which committed such brutality in East Timor, are now at war in Aceh, given a free hand by the Megawati government. There have been countless waves of human rights violations by the army in West Papua. Using the "threats" of separation and terror as pretexts, the army is making an alarming political comeback.

The solidarity movement proved to be a weapon more powerful than guns. Now that the guns are silent in East Timor, its task is more complex but just as important. The world must not be allowed to forget the East Timorese. There is still a need for solidarity, to help their voices be heard and justice to be done, and to stand in support of human rights throughout the region. ■

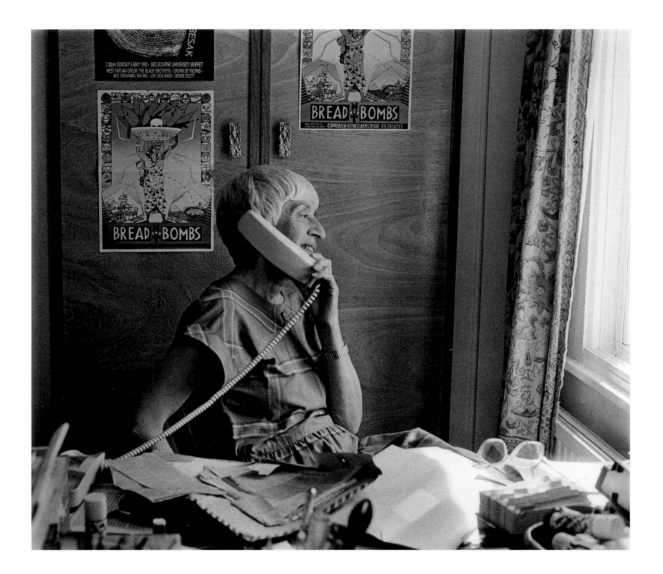

Carmel Budiardjo, TAPOL, London, 1993 71

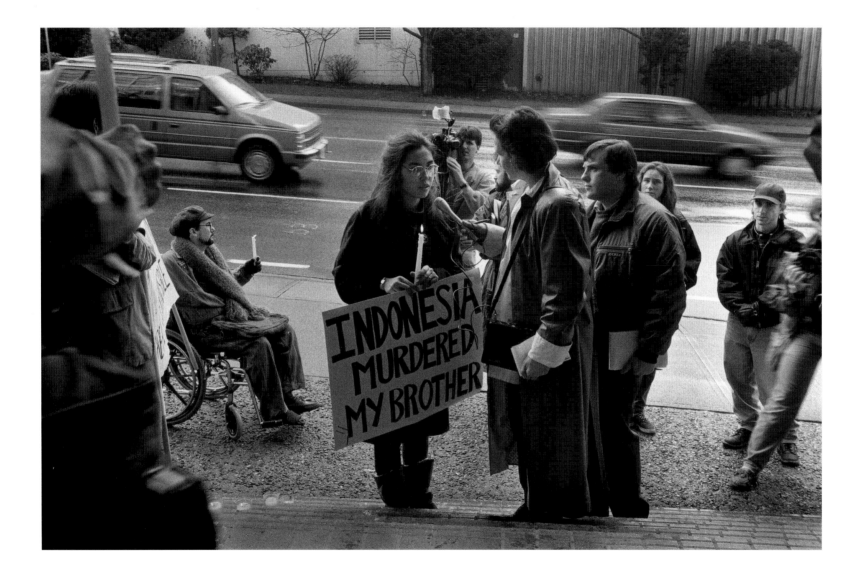

Demonstration, Indonesian Consulate, Vancouver, 1991

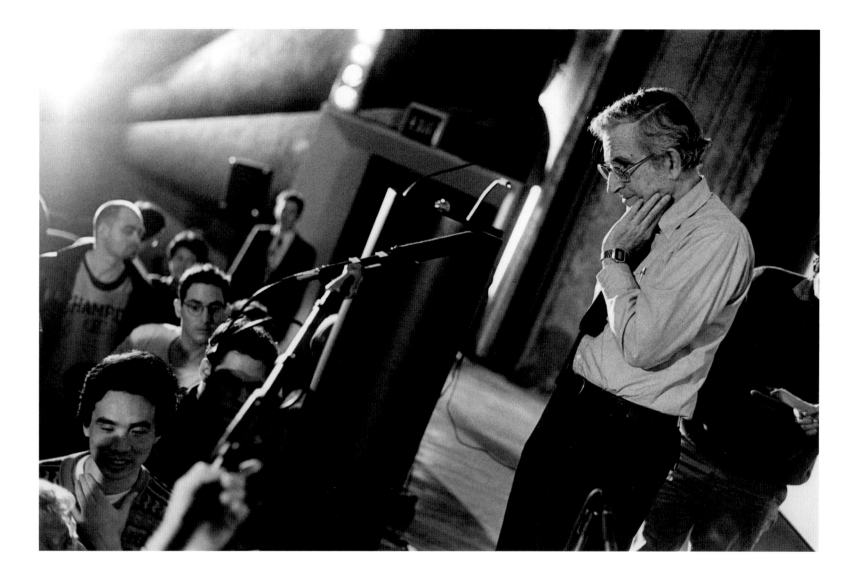

Noam Chomsky, Ridge Theatre, Vancouver, 1996

André Ouellette, Minister of Foreign Affairs, Ottawa, 1995

Museum of Civilization receiving presents from the Indonesian Embassy, Ottawa, 1995 75

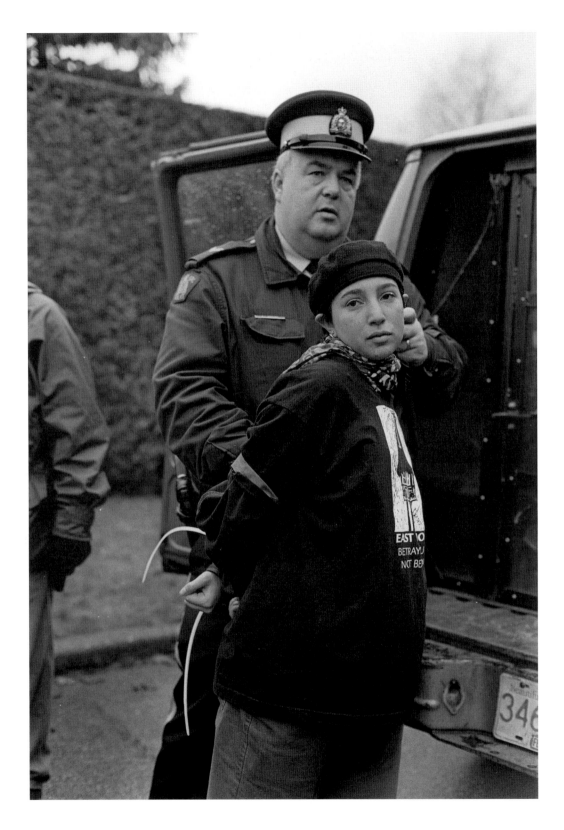

76 APEC protests, Vancouver, 1997

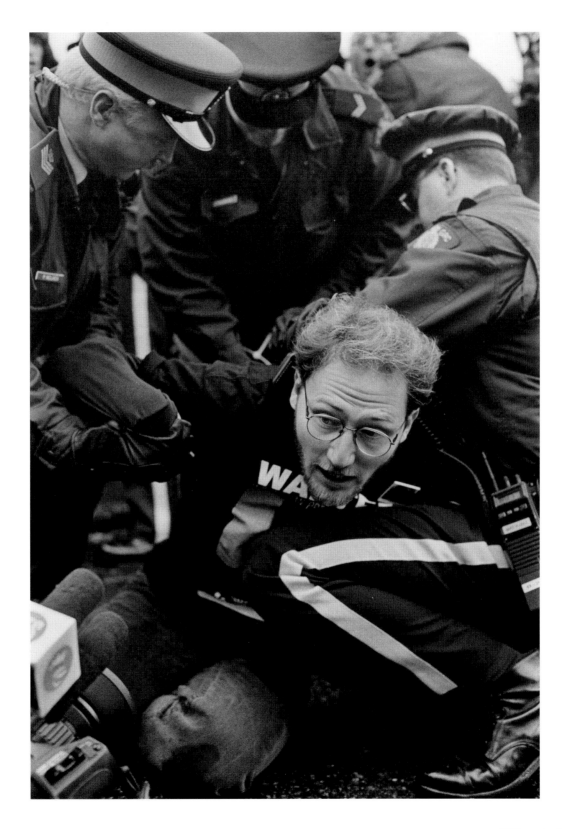

APEC protests, Vancouver, 1997

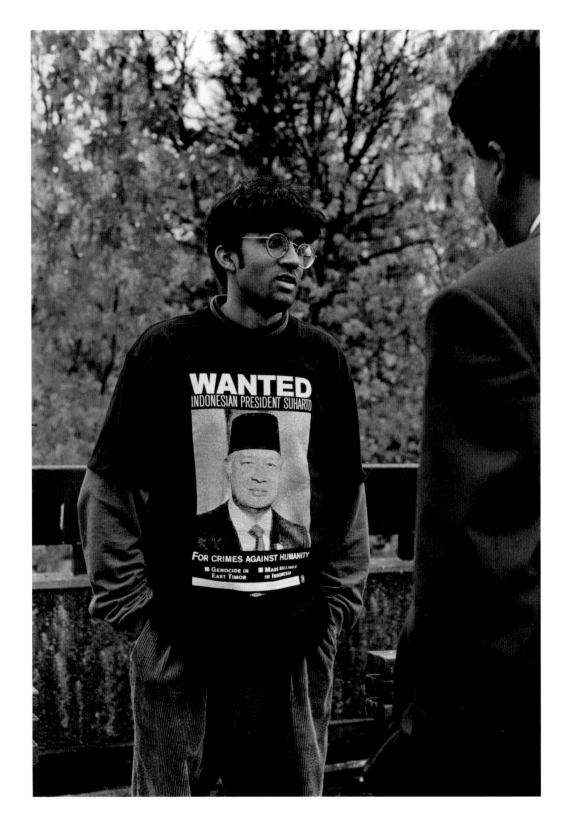

78 Jaggi Singh, APEC protests, Vancouver, 1997

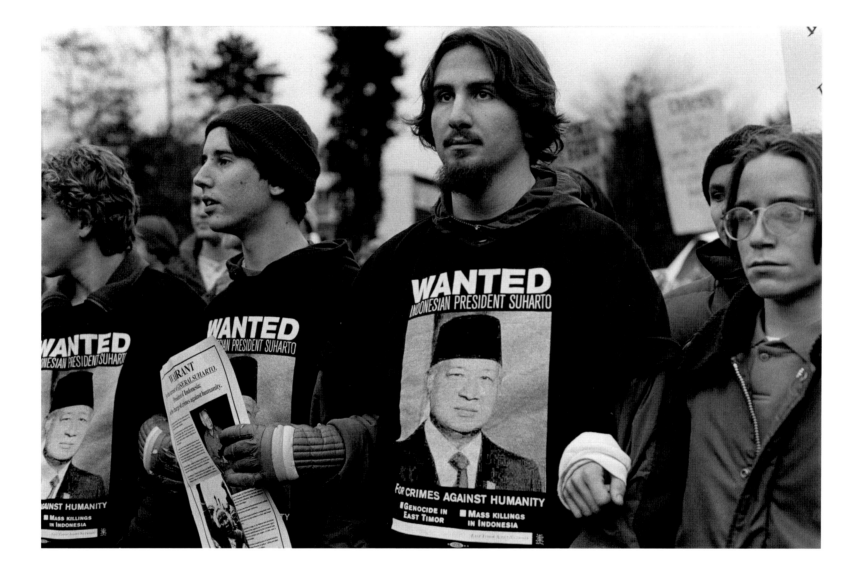

Anti-Suharto Tribunal, APEC, Vancouver, 1997 79

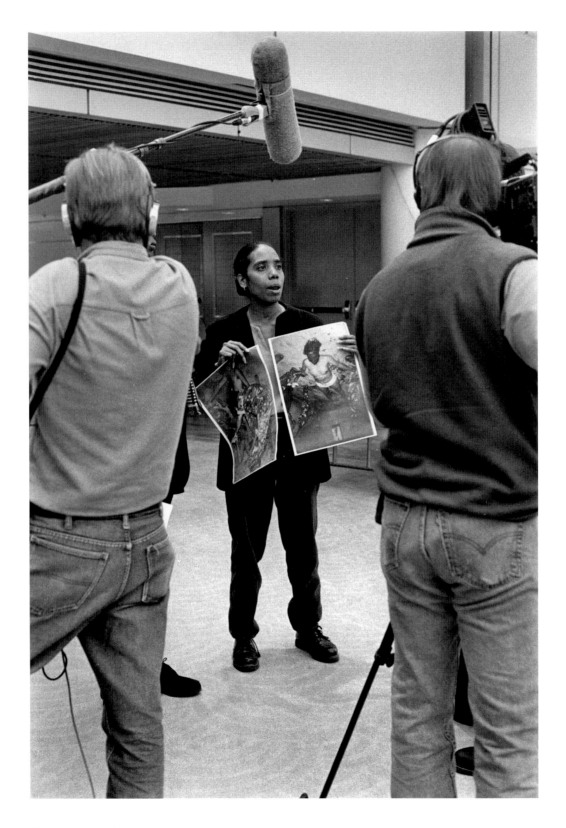

80 Isabel Galhos, press conference, APEC, Vancouver, 1997

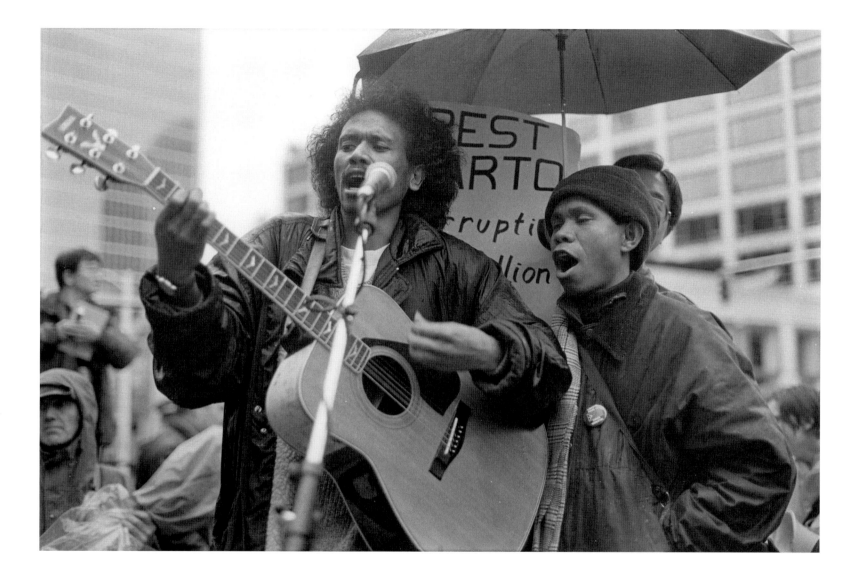

Timorese anti-Suharto protest, APEC, Vancouver, 1997 81

82 East Timor Alert Network with Constância Pinto (far right), Vancouver, 1992

JAMES DUNN

Living with timor: tragedy and hope

It was in 1945 as a teenage soldier in the Australian army that I first became aware of the existence of Portugal's Timor colony. I sighted the mountainous island from the deck of our crowded troopship, which had just left northern Australia. We were heading for Japan, to participate in its post-war occupation. Timor loomed mysteriously on our port side, its rugged peaks shrouded in mists. The Timorese had just been liberated from more than three years of Japanese occupation. At the time it seemed a shadowy, mysterious land, its inhabitants invisible to a party of curious Australian troops who knew nothing of their ordeal during the war. Ten years were to pass before I gave any serious thought to this remote outpost of Portugal's rambling empire.

The East Timorese were some of the worst victims of the Second World War. Their enthusiastic support for an Australian commando force led to a harsh occupation by Japanese forces once the Australians had withdrawn. Their towns and villages were then bombed by Allied aircraft, for Timor was the nearest occupied territory to the large Allied airbase at Darwin. The war cost East Timor about 70,000 lives and the destruction of most of the colonial power's very mod-

est achievements by way of development. It suffered heavier losses than any other territory in Southeast Asia.

I was soon to be confronted by another tragic situation for my unit was stationed just outside Hiroshima, where we were to face the discomforting reality of a Western atrocity. That terrible scene activated my conscience, later influencing my Timor experience. Both presented the hidden side of human suffering that governments would rather hide from us. Nothing, it seemed to me at the time, could have inflicted more killing and destruction than an atomic bombing. And the victims were not soldiers or political leaders. Most were civilians, many of them children, doomed to die from their atomic burns in the next year or so. Hiroshima made me question a lot of things, not least the bias of wartime propaganda, and the cruel nature of modern war.

It was years later when Portuguese Timor next came to my attention. Then I was one of a small group of students, pioneers of the study in Australia of the history and politics of Southeast Asia. Our main focus was the region's turbulent decolonization. Most of my university colleagues dismissed the Portuguese colony as an anomaly, an insignificant

territory, when compared with Indonesia, Indo-China, or Malaya. Indeed it was usually treated with derision, for there was neither a Timorese independence movement nor any dissident activity. Such views were also common to analysts in our defence department, which I joined in the mid-1950s, and where I soon became a specialist on Indonesia's politics and military.

In the context of Indonesia, East Timor was a curiosity, and events there of only marginal interest to the Australian government. Nor did East Timor appear to interest President Sukarno, who seemed unconcerned about the colony's status at a time when Indonesia was denouncing colonialism elsewhere in the world, and was laying claim to West Papua, then under Dutch rule. By the early 1960s Sukarno's campaign to "regain West Irian" (as Indonesia called the territory) had reached fever pitch. Having been persuaded by the CIA that opposing this campaign was playing into the hands of the Indonesian Communist Party – the PKI – Washington did what diplomats call a volte-face, and withdrew its support for the Dutch presence. Australia also reluctantly backed away from its support for the Dutch, and West Papua was subsequently transferred to Indonesian rule, following a farcical "act of free choice."

Portuguese Timor got little attention from us. An exception was one of my defence colleagues who had served as a commando in the territory during the war, and deeply admired the Timorese people. His stories about their courageous support of the Australian force, despite Japanese threats of severe reprisals, impressed me. Australia was clearly indebted to the people who had made such efforts on our behalf, when an invasion of our continent seemed imminent. Yet that debt was never formally acknowledged by the government or politicians. The East Timorese got no compensation from Australia in the post-war years to atone for the terrible impact of a war

they might have escaped if the Allies had not intruded and violated the colony's neutral status (Portugal was neutral).

It was at that time, some forty years ago, that my involvement with East Timor began in earnest. With Indonesia now certain to get West Papua, East Timor (our politicians concluded), was bound to be next on Jakarta's agenda. It was in these circumstances that I was offered the post of Consul in Dili – my single status, my knowledge of Indonesia, and my ability to speak the language my essential qualifications.

The East Timor I encountered was indeed a sleepy backwater. Dili was a small, underdeveloped town of some 14,000 people. Its buildings were a mix of Portuguese-style houses, in their distinctive pastel colours, and the traditional bamboo cottages of the Timorese and most Chinese. Conditions in the capital were primitive; it was at first without electricity, and the roads were unsealed. However, the great majority of the population lived in small villages along the coast and in the mountainous interior. If Southeast Asia was in post-colonial turmoil, East Timor was extraordinarily untroubled during my years as consul. I was ever on the lookout for dissident or independence movements, but encountered none.

The Portuguese colonial order under Salazar was authoritarian in nature, though not particularly oppressive. Timor was more or less sealed off from the rest of the archipelago. The socio-economic scene was, in some ways, classically colonial. The Portuguese were the ruling class, the commercial sector was dominated by the Chinese (some of whom had been there for more than a century), and the Timorese were controlled by their feudal structures, with most people struggling in poverty at the bottom of the socio-economic ladder. There was less racial discrimination than in most colonial situations, but there was also very little development, for Portugal's economy was too weak to service its most remote and least important territory. There were some primary schools, but apart from the Jesuit seminary there was only one high

school, the Lyceum, from which emerged a trickle of educated Timorese, who were then absorbed into the civil service or the army.

I had expected to encounter challenges to Portuguese colonial rule, but there was nothing to disturb the calm of the province (as it was designated). This tranquillity was largely the result of the colony's isolation from Indonesia. The Timorese did not speak Indonesian, and the border was closed, except for some movement in the Belo areas to the southwest. If there was a centre of questioning, it was the Dare Seminary (Seminário da Nossa Senhora de Fátima), where young priests, or at least some of them, were encouraging their students to look beyond the limited horizons offered by Portuguese colonialism. Young Portuguese officers, some of them university student conscripts with radical views, also set out to enlighten young Timorese army recruits. But in the early 1960s, these channels of enlightenment had yet to make a noticeable impact on the Timorese. Clearly, however, the indigenous people deserved better than their impoverished and servile conditions under colonial rule.

For me, life in Timor in those days was an intimate and stimulating experience, and one that stayed with me during later postings in Paris and Moscow. East Timor offered something special to the diplomat: it was small enough for one to get to know the colonial rulers, the people, and most aspects of their intricate environment.

The Lisbon coup in April 1974, which ended the Salazar dictatorship, was responsible for my return to Timor, this time as the expert member of a fact-finding mission, with the task of reporting to the Australian government on Timor's future. As far as the Timorese were concerned the scene had radically changed. The colony now had an educated and vocal minority, who were enthusiastic for independence. The streets were alive with young people, most brimming with confidence that they could manage their own destiny. Less enthusiastic were the older generation and some of the Portuguese. Remarks like "these people could never rule themselves" usually came from those who resented the ending of their colonial privileges.

There was an assumption in Canberra, one shared by a few Portuguese officials, that East Timor was not viable as a state and would be better off as part of Indonesia. It was a cynical and simplistic view, a reminder of the vulnerability of small states and territories in a world so easily swayed by power. If the Timorese had wanted to join with Indonesia it would of course have been fine, but our fact-finding mission dismissed that option as unrealistic. They had no wish to become part of Indonesia, the great majority insisting on their right to choose their own future. This trend did not impress Prime Minister Gough Whitlam and many other Australian politicians, and I soon found myself rather isolated. Australia's official response dismayed me. It was cynical and shortsighted, and I could not go along with it. I was to become a kind of dissident, who survived because of my independent post as a senior foreign affairs advisor to the Australian federal Parliament.

In late 1975 I was confronted with the awful reality of Indonesian aggression. I had agreed to lead an NGO aid mission to East Timor, with a mandate to seek an end to the violence that had erupted during a brief civil war between the Fretilin and UDT parties. It was during this time that the Indonesian invasion began in earnest, and eventually I was forced to flee to Australia from Dili. The army's major assault on Dili soon followed, and many of the Timorese who gave me a tearful farewell were to lose their lives. In fact in the following four years, according to church sources, as many as 200,000 people or almost a third of East Timor's population died, as direct or indirect consequences of the annexation. While this became known to western diplomatic and intelligence services, there were no serious moves (except by Portugal) to press Indonesia to withdraw.

As one of the few outsiders with knowledge of the territory, I made regular trips abroad, speaking on behalf of the Timorese, usually in response to the concerns of non-governmental organizations. For most governments East Timor's annexation, however regrettable, was a *fait accompli*. While it is true that the 1991 Santa Cruz massacre and the ending of the Cold War returned the Timor problem to the international agenda, Indonesia's acceptance of UN intervention was brought about by an unrelated event – the fall of President Suharto following Indonesia's economic collapse. President B.J. Habibie's change of direction led at last to an act of self-determination in 1999, under the careful supervision of a UN mission.

I found myself again in East Timor as a UN observer of a process we had long struggled for. It was an exciting time, an unforgettable demonstration of the determination and courage of the Timorese people, who defied massive intimidation and voted to separate from Indonesia. It was a decisive outcome, justifying our long commitment to their cause, and led to a brief emotional celebration at Dili's Mahkota Hotel when the results of the plebiscite were announced. Our joy was short-lived, however, for within an hour the Indonesian army and their militia swept into Dili, and began a massive campaign of destruction. For the third time in less than sixty years the courage of the people of East Timor was again sorely tested.

During the first stages of this violence I remained in Dili. I was evacuated, leaving a city in flames with its citizens at the mercy of their attackers. I made an attempt to get to a Timorese family with whom I had stayed, but their village was burning. And so, for the second time in twenty-four years I fled East Timor. My feelings as our Hercules aircraft left Dili are difficult to describe. I was in a state of grief, distressed at what looked like another failure to rescue the people of this remote land.

This time, however, was different. A fortnight later international forces began to arrive, and then the Indonesian military commenced their withdrawal from the territory. I eagerly accepted requests to help the UN begin the task of healing East Timor's terrible wounds and preparing for independence, and have spent much of the past four years there, as a lecturer at a school for Timorese diplomats, and as a UN expert on crimes against humanity.

Full independence came quickly. On May 20, 2002, more than forty years after I had first set foot in East Timor, the territory changed its status from a UN mandate to an independent state. I shared the excitement of the occasion, though for me it was something more. East Timor had become an inextricable part of my life. I thrilled at its successes, worried over its failures and inevitable setbacks. I do, however, have confidence in this new nation's future. The destiny for which its people struggled so determinedly will be fulfilled. ■

View on the road to Kelikai, 2000

Outrigger canoes, Dili, 2000

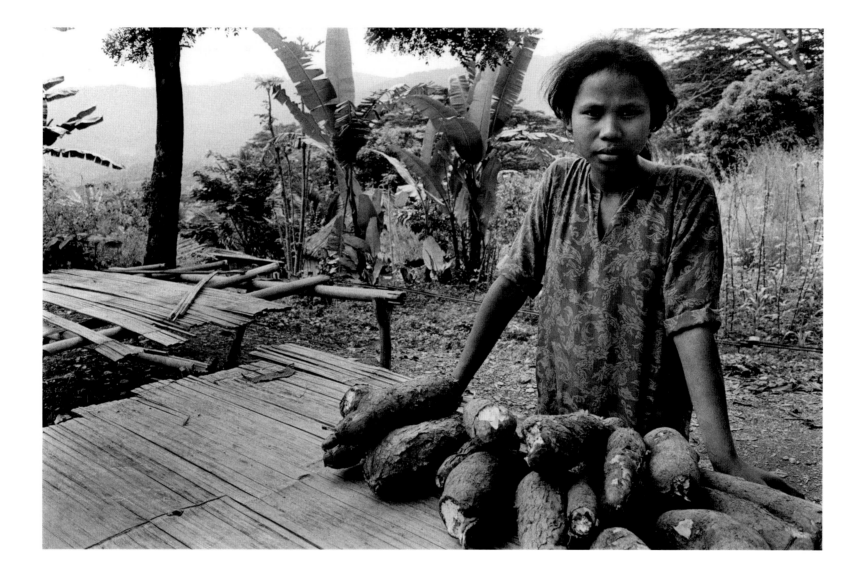

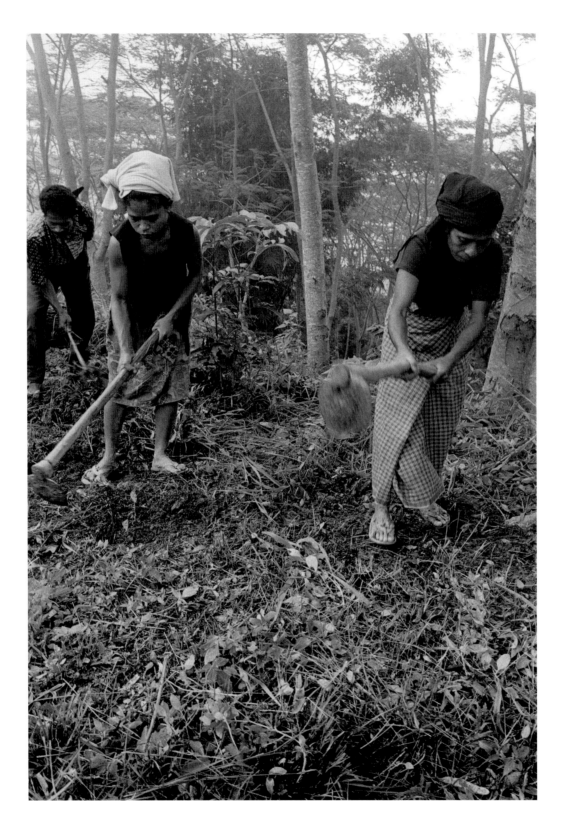

Road crew, Aileu, 2000

PART 3 | **ONWARDS**

INÊS MARTINS and
ANDREW TEXEIRA DE SOUSA

Building the
new East timor

For a quarter of a century, East Timor fought a *luta*, a struggle, for independence. Now East Timor has to decide how to exercise that independence. The next *luta* is a struggle for people-centred development.

When the Portuguese first arrived in East Timor in 1515, they encountered about 300,000 people with their own social structures. The liurai, local chieftains or kings, were a central part of society. They were expected to rule with sincerity, humility, and understanding. The people entrusted the liurai to look over them and would follow their judgment. East Timorese lived by subsistence agriculture, from crops such as corn, potatoes, cassava, rice, coconuts, and bananas. The Portuguese began establishing relations with the East Timorese through the liurai, adapting the system for their own purposes in order to control the population. The merger of liurai and Portuguese fascist colonialism stunted the nation's development, and it was difficult for the people to make any gains against poverty.

Society was discriminated by class and race. At the top of the structure were the Portuguese, living in urban areas. Under them were the mixed-race Mestizos, followed by the ethnic Arabs and Chinese. Indigenous East Timorese came last, and were always the lowest priority in education, health, and social services. They were divided into the *assimilados*, who had assimilated into Portuguese culture, and the "backwards" peasant majority, dismissed as Maubere, after a common greeting used by the Mambai people.

The Portuguese regime opened schools only in the cities, leaving behind the vast majority of East Timorese, who lived in villages. By the end of Portuguese rule there was only one high school and a seminary, both in the largest city, Dili, and no university in the entire country. For the few lucky enough to receive the maximum education available in the country (nine years), the only way to continue their studies was to go abroad. Moreover, the underdeveloped economy had no places for people with higher education. The core of East Timor's present leadership comes from this small elite who had some access to formal education.

The economy remained underdeveloped due to a lack of qualified people and technical expertise. Only small markets were created to export the riches from East Timor, such as coconut, coffee, sandalwood, wax, and bananas and to sell

products imported from Europe and elsewhere. Markets were used for goods to enter and exit the country, but the Portuguese put no effort into developing agriculture. The focus was on how to exploit the existing products cultivated by the people, resulting in famines from the lack of agricultural development. In this period no industries or investment went into East Timor, and farmers had no possibilities or power to develop their production. They were limited to selling their few products at deflated prices to Portuguese government companies such as SAPT and Santai-Ho, which would export the products and keep the profit for themselves.

Little was invested in infrastructure: the country had small and simple housing, poor roads that did not even service all the villages, and virtually no telecommunications. Adequate roads were built only in Dili for the elite, but peasants were not entitled to such basic services.

Health care was extremely limited, with only two hospitals (in Dili and Baucau) and almost no rural health service. One nurse would be assigned to cover an entire sub-district. The nurses were overworked, and had to travel around the sub-district by horse or by foot. The Portuguese failed to invest in doctors, medication, or transportation, offering little improvement in health care.

Portuguese neglect did have one up side: by forcing village people to rely on their own abilities, it left traditional social structures intact. Resourceful people living in remote areas developed sustainable farming systems in their mountain gardens. These methods produced far more food than Portuguese coffee plantations, while doing far less violence to the environment.

So East Timor emerged from the colonial period self-sufficient in food production, unlike many other colonies in Southeast Asia. Despite Portuguese inroads, its economy was largely directed towards feeding its people. Traditional structures had proven resilient in the face of colonialism, and were poised to enter a new post-colonial period with several advantages.

When the East Timorese people seemed finally to have the chance to be rid of the Portuguese and develop their country, Indonesia invaded. Indonesian rule under a corrupt and brutal military was chaotic. Attempts were made to develop the country – especially in health, education, and infrastructure – so the East Timorese and the international community would accept the occupation. However, the development did not benefit ordinary people: it was meant to serve the needs of the regime, and much of it was lost to corruption. Indonesia's national symbol is the mythical Garuda bird. By the time the Garuda reached East Timor, people used to say, it had already lost all its feathers.

Many schools were opened, reaching the village level and providing access to education to many more people. But the quality of the system was poor, and did little to build capacity among the people. The focus was solely on literacy, and did not address the need for professional skills. More people were able to get university degrees, but few could get jobs of importance under the Indonesian regime.

The economy remained underdeveloped, with the Indonesian occupiers replacing their Portuguese predecessors. Indonesian businesses with ties to the military monopolized the country and had military support in discouraging local competition and entrepreneurship.

Many advances were made in infrastructure, but the system was poorly constructed and expensive to maintain. Still, many houses and offices were built. Transportation developed with greatly extended and improved roads, primarily to aid the military's movements across the country.

Although there were some positive developments during the Indonesian period, they were made not so much to eliminate poverty as to build Indonesian nationalism and

win the "hearts and minds" of the East Timorese. In 1999, when an overwhelming 78 per cent chose independence, the Indonesian leadership was embarrassed before the international community. For years they had claimed the East Timorese wanted integration with Indonesia, which had done so much to help the country. Many accused East Timor of "ingratitude," although East Timor had never asked for the Indonesian presence.

With the referendum, even the military's trusted Western allies could no longer pretend to believe their lies. The people had been anticipating the Indonesian military response, and had begun to take refuge in churches before the results of the referendum were announced. The Indonesian military and their militias carried out a scorched earth campaign, murdering anyone from small children to the elderly, raping women, looting and burning houses and possessions, and forcing the evacuation of hundreds of thousands of people to Indonesia. Other East Timorese fled to the mountains. The international community finally began to recognize the violations of human rights that the East Timorese had been suffering for so long. When international forces intervened on September 20, 1999, most of the country had already been burned to the ground. The Indonesian military wanted to eliminate anything that the East Timorese had "gained" under Indonesian rule, and they exceeded their goal. East Timor finally was getting its independence, but it had to start from ground zero.

East Timor is still in dire need of assistance. After the post-referendum violence, the international community promised to aid East Timor with reconstruction and to prepare the country for a stable independence. The donors promising the majority of funds for East Timor were all nations involved in creating the tragedies that befell it. Among them were the US, the UK, and Australia, which supported the Indonesian military throughout the occupation. There was also the World Bank, which had supported the Suharto regime to the tune of

US$1 billion per year, and Portugal and Japan, both of which had invaded East Timor before Indonesia. The international community took twenty-four years to stop supporting the Indonesian atrocities, but was quick to enter with the international aid industry, led by the UN, foreign government agencies, and international NGOs. The support now being provided cannot erase past atrocities, and is not comparable to the profits these countries enjoyed in the past, but it is an initial repayment of what they owe the Maubere people.

The United Nations Transitional Administration for East Timor (UNTAET) was established to provide military security and prepare the nation for independence and future development. The international administration put supreme power in all branches of government under the Special Representative of the Secretary-General of the United Nations, the Brazilian bureaucrat Sérgio de Mello, effectively creating a benevolent dictatorship. UNTAET often used words like "capacity building" and "Timorization" but was slow to provide adequate training or give decision-making power to the East Timorese. When the mission was "completed" in May 2002, East Timor had a government and constitution, but two hundred international staff were still needed to help run the government.

Besides the United Nations bureaucracy, International Financial Institutions (IFIS) also became powerful players in post-referendum East Timor. The World Bank had begun planning East Timor's development future before the referendum. When the reconstruction process began, donor governments gave about US$166 million to the World Bank's Trust Fund. Together with the Asian Development Bank, the World Bank began projects in infrastructure, health, agriculture, education, and private enterprise. The World Bank did not accommodate local participation and imported its own programs and methods, assuming that the East Timorese people agreed with its market fundamentalist ideas. Rather than support the local economy, much of the Trust Fund money went to foreign

companies and consultants. Although the Trust Fund projects helped begin the process of reconstruction, the results were meagre in relation to the money spent.

The World Bank now controls a new Trust Fund, pooling donors' support for the East Timorese government budget. The government has been fighting hard to minimize World Bank influence, but the struggle over who will control the country's development process is ongoing. The World Bank's sister institution, the International Monetary Fund (IMF), is also active in East Timor, working to develop the government's financial system and laying the groundwork for a central bank. Despite its small mission, the IMF has considerable influence on macroeconomic policies. One example is IMF success in avoiding democratic methods to choose an official currency, convincing UNTAET and the embryonic East Timorese administration to agree with the IMF's choice of the US dollar.

Many donor countries who supported Suharto are now contributing to East Timor's development, as defined by their own interests. Portugal has some of the most noticeable bilateral projects, attempting to recolonize East Timor through intense promotion of Portuguese language and culture. The US gives considerable support to civil society and the media. These funds help local organizations contribute to the nation's development, but large amounts go to administration and American NGOs that act as "middlemen." Local organizations are treated with far less respect or trust than international NGOs. The largest project from the US government began before the referendum: the creation of a coffee company, a capitalist-based co-operative. Perhaps it is only a coincidence that the US government promotes the coffee sector as a way to develop East Timor – the international coffee market is unbalanced, with great instability for producing countries like East Timor, while guaranteeing large profits for companies in consuming countries such as the US. Canada is not a large donor, but gives some support to local NGOs and the government budget.

As the aid industry became distracted by other Western-created disasters like the US interventions in Afghanistan and Iraq, their commitment to develop East Timor began to decrease. When UNTAET left on May 20, 2002, independent East Timor was faced with several challenges.

Economically, the country has to deal with new inequalities created by the large numbers of overpaid foreign staff and a foreign-dominated service industry to provide for them. Many children who lost their families during the occupation are hawking goods in the street to foreigners instead of going to school, and prostitution has grown with the large numbers of UN peacekeeping soldiers. Frustration with the economic situation has resulted in sporadic violence in the capital, such as the looting and burning of foreign businesses and buildings in December 2002. Conditions for groups such as local merchants and farmers need to be improved so the local economy can survive.

The government has identified education as one of its highest priorities, but there is much to be done. Many students had their studies interrupted in 1999 and most of the teachers were Indonesians who left the country. There are severe shortages of qualified teachers and basic necessities such as books, desks, and schools. Confusion abounds with a mix of Indonesian- and Portuguese-based curriculums in a transition to a Portuguese language system. Administration is difficult with a lack of regulation to govern emerging private institutions.

Infrastructure is still behind pre-1999 levels, with roads continuing to deteriorate, especially during the rainy season. The government struggles with an inefficient diesel fuel-run power system, and frequent blackouts occur in the few areas that have access to electricity.

In the health sector there is some support from donors, supplying doctors, medicine, and money, but much of the assistance is wasted on the expensive administration of international institutions. The government is forced to go along with the donors' plans rather than having the freedom to create their own system.

The under-resourced government has to deal with these pressing issues and many more, and needs to determine how to work together with the people to find solutions. Before independence, the embryonic East Timorese government under UNTAET and the donors created a National Development Plan. The plan has many problems: despite stated intentions to create it with public participation, donors rushed its completion, leaving little time for consultation. The result was a plan written in English – which few East Timorese can understand – that promotes free-market ideology and gives priority to the private sector. As with most development projects in the country, the plan is centred in Dili. It has some positive aspects, including a priority on health and education (the government budget commits a higher percentage to social services than most governments in the world). And the plan at least has provided a temporary alternative to a World Bank Poverty Reduction Strategy Paper (PRSP). However, because the World Bank will continue to advocate for a PRSP, it is essential that the National Development Plan be strengthened through public revision.

The government needs donor support to rebuild the country, but must also protect the nation's interests when dealing with donors. The money that is coming into East Timor during this period should remain here, not immediately be passed into the hands of foreign consultants and businesses. The East Timorese government has much work to do, but few financial or human resources, and a serious lack of qualified professionals. Just as the East Timorese people unified to defeat the Indonesian occupation, we must unify now to fight for our common interests. The government needs to work more closely with the people to deal with the nation's problems.

Relations between the government and the people are problematic in part because of poor communication. Local administration is not fully functional, making it difficult for the majority of people who live outside of Dili to raise issues with the national government. Only sporadic attempts are made to inform the people of the government's activities or to bring them into the decision-making process. The nation's future development greatly depends on what path is chosen today. If the government chooses to follow the interests of the political leaders, the nation as a whole will not develop much. If it follows the interests of the people as a whole, then the entire nation will be able to develop together. In order to gain the people's trust, the new government must be publicly seen as choosing the second option.

A future test of the government's priorities is emerging with the oil and gas reserves in the Timor Gap. Will the government be able to protect the nation's wealth and use the revenues to benefit all the people? The government expects significant revenues to become available in 2004 and help with development programs, but what will it do if the revenues don't materialize? The nation should not be too dependent on these resources, and the government must be committed to maximizing the benefits and minimizing the risks associated with oil and gas extraction.

The people are used to being self-sufficient and capable of developing on their own with meagre resources. All over the country people mobilized to resist the Indonesian occupation, and now they continue to mobilize to improve their lives and develop their country. Examples can be seen in villages across East Timor: farmers in Maubisse organize into co-operatives so they can produce higher-quality products, and use the same groups to grow through popular education.

The villagers of Bucoli are teaching each other to read and write. In Uatucarbau, there is no school close by, so the community built one to give their children an education. Despite all the difficulties they are facing, the East Timorese people are finding ways to move forward. They could accomplish much more with more resources, and they should be assisted to do so, but only in ways that respect their autonomy and allow them to continue to lead the process.

The East Timorese people have fought hard for their freedom and dignity, and do not want to be dependent on international assistance. We united to defeat the Indonesian military, and won against insurmountable odds. Now we have political independence, but we are still enslaved by poverty and injustice. As we say, *a luta continua!* – the struggle continues – and together we can win. ▪

ADRIANO DO NASCIMENTO and
CHARLES SCHEINER

the Gap in East timor's Independence

East Timor became a self-governing nation in 2002, but the territorial and economic independence of the new state are yet to be achieved. Sandwiched between two huge countries that collaborated to illegally and brutally occupy its land territory for a quarter-century, the tiny nascent nation is still struggling for its freedom. East Timor's independence will not be fully realized until its boundaries – both land and sea – are well defined and accepted by its neighbours.

The Timor Sea between East Timor and Australia – and the oil and gas that lie under it – is a potential solution to many problems. The revenues to be reaped from undersea petroleum resources – perhaps as much as US$30 billion over three decades – could help East Timor become independent of donor support and escape from being the poorest, unhealthiest, most unemployed, and least literate country in Southeast Asia.

East Timor endured colonialism for centuries. Portugal colonized East Timor for 450 years, Japan for three and a half years and Indonesia for twenty-four years. During those periods, however, the East Timorese spirit of nationalism and patriotism could not be stifled.

East Timorese fought to liberate the nation and the people from all these colonial rulers. Many people sacrificed their lives, dignity, and property to achieve these goals. Families lost their loved ones during the struggle, many women lost their dignity because they were raped, children lost their parents, and people suffered enormously. These are the prices every East Timorese person has paid in the struggle to achieve their sovereign nation. All those sacrifices were not in vain: they succeeded when the Democratic Republic of East Timor became an independent state in May 2002. The new nation's legitimacy is accepted by the entire international community – all three former colonial powers have joined the rest of the United Nations in welcoming its newest member.

However, East Timor achieved its independence without defining its maritime boundaries, and the majority of the petroleum is in territory claimed by both East Timor and Australia. Australia refuses to negotiate boundaries, rejects international legal principles and processes for resolving boundary disputes, and is taking in billions of dollars – far more than it has given East Timor in aid – from oil fields it occupies by

force. Australian control of these oil fields leaves East Timor's independence incomplete.

With political independence achieved, East Timor has a chance to become economically independent and escape from poverty – if Australia agrees. But so far, Australia seems inclined to try to use Timor Sea oil to grow richer itself.

For many East Timorese, money is not the most important issue. Although the Australian government has convinced East Timor's leadership to accept interim arrangements to allow oil revenues to begin flowing to Dili, many people do not feel their sovereignty should be traded for quick cash. As one pro-independence leader said, "If we wanted money, we should have stayed with Indonesia. They were giving East Timor development and infrastructure to try to buy off our people. Our families didn't die for money – we died for freedom. And how can we have freedom if we don't know what is East Timor's territory and what is not?"

Australia is much larger, richer, more experienced, and more developed than East Timor. It has four times as much gas outside the Timor Sea as under it, and is assured of energy and income for decades to come. Australia is also a stable, English-speaking, mostly white member of the club of "Western" nations preferred by oil companies and diplomats alike.

East Timor, on the other hand, is new at self-government, with limited human and almost no material wealth. It has no other significant export resources, and will be critically dependent on Timor Sea revenues as foreign aid dissipates or is distracted over the next few years. And its recently victorious struggle and lack of history with the industry make the oil companies uneasy.

The Australian government claims to be generous to its new northern neighbour. Australians also think that their aid to East Timor has helped rebuild the country from the 1999 military/militia destruction. They are only beginning to understand that Australia has stolen more oil revenue from East Timor since 1999 than it has given in aid, and that Canberra continues to illegally occupy valuable areas of East Timor's maritime territory.

Australia's policies on the Timor Sea issue insult the value of the struggle of East Timorese to liberate their nation and the dignity of people who died for their rights to land and sea. Without military or political might or international support, East Timor's only option is to wait patiently, hoping that the people of Australia will demand that their government act in the democratic, law-abiding, fair and civilized tradition that their country claims to uphold.

In 1972, while East Timor was still under Portuguese colonial rule, Australia and Indonesia divided the seabed between them. Since Portugal refused to take part, the Australia-Indonesia boundary line had a hole in it. The resulting break in the 1972 line is called the Timor Gap. In Portugal's absence, the two powers made the Gap as narrow as they could – it is 128 miles (206 km) long, about 30 miles (48 km) shorter than the land of East Timor. Neither East Timor nor Portugal participated in the treaty processes, so that agreement has no relation to the territorial rights of the now-sovereign Democratic Republic of East Timor.

The 1972 line was based on the now-outdated "continental shelf" principle, and follows the deepest water between the countries, the 2500-metre-deep Timor Trough.

In 1975, Indonesia invaded East Timor, with support from Australia, the United States, and other countries. As the ensuing brutal occupation was killing hundreds of thousands of East Timorese, Australia and Indonesia began negotiations to close the Timor Gap and begin exploiting the lucrative resources in its vicinity.

At the same time, the nations of the world were negotiating the United Nations Convention on the Law of the Sea (UNCLOS) to regularize settlement of seabed boundary disputes, which had often been unfair and ad hoc. UNCLOS,

signed in 1982 and ratified by Indonesia (1986) and Australia (1994), specifies that each nation can claim an exclusive economic zone (EEZ) extending 200 nautical miles from its shoreline. Where such claims overlap, the normal boundary would be along the median line, halfway between the nations' coasts. Most of the oil and gas in the Timor Sea lies south of the Timor Trough and north of the median line (dashed on the map), closer to East Timor than to Australia.

After a decade of discussion, Australia and Indonesia signed the Timor Gap Treaty in 1989. Instead of completing the 1972 boundary line or following UNCLOS principles, they created a Zone of Cooperation (ZOC) within which the two countries would equally share oil development and profits. The Timor Gap Treaty was clearly unfair to Indonesia – the cost of Australia legally accepting the illegitimate military occupation. It became effective upon ratification in 1991. Portugal challenged the treaty in the International Court of Justice, but since Indonesia does not accept ICJ jurisdiction, Australia was the only defendant. The court ruled in 1994 that East Timor has a right to self-determination, but they could not invalidate the treaty because Indonesia was not present.

The first oil and gas exploration contracts were signed in December 1991, while the blood was still drying from the November 12 Santa Cruz massacre. The companies that are Timor Sea operators today – Phillips Petroleum (now Conoco-Phillips), Royal Dutch Shell, and Woodside Australian Energy – all joined in the initial, illegal gold rush. The Elang-Kakatua oil field, which started production in 1998 and is now fully depleted, paid nearly all of its revenues to Australia and Indonesia.

East Timor remained under illegal occupation and the Timor Gap Treaty remained in effect until October 1999. Following the referendum and Indonesia's violent withdrawal from East Timor, the United Nations assumed transitional powers. The UN and East Timor's leaders wanted oil develop-

ments to continue uninterrupted, and the UN Transitional Administration (UNTAET) signed a memorandum with Australia in February 2000, continuing the Timor Gap Treaty but replacing the word Indonesia with East Timor. Under pressure from the oil companies, the arrangement was formalized in July 2001. The Timor Sea Arrangement re-labelled Area A of the Zone of Cooperation from the 1989 treaty as the Joint Petroleum Development Area (JPDA). However, it divided revenues 90 per cent for East Timor and 10 per cent for Australia, while maintaining a 50-50 division of authority over the joint area, which contains the Bayu-Undan oil and gas field, scheduled to be in production in 2004. Bayu-Undan's gas will be shipped via pipeline to Australia for liquification and export, giving Australia most of the employment and tax revenues. Although Australia claimed to be generous, by rights the JPDA is 100 per cent East Timorese. UNTAET and Australia refrained from discussing areas outside the JPDA – in effect legitimizing Australia's illegitimate possession of those areas – but reserved maritime boundaries for settlement in the indefinite future.

In March 2002, Australia gave formal notice that it would no longer participate in international legal arbitration through the International Court of Justice or the UNCLOS Tribunal to resolve boundary issues that cannot be settled by negotiation.

On the day East Timor became independent (May 20, 2002), the new government signed the Timor Sea Treaty (TST) with Australia, which essentially continued the Timor Sea Arrangement from 2001 – not surprisingly, since the Treaty was negotiated during the same UN administration that had negotiated that arrangement. The two countries agreed to "unitize" the vast Greater Sunrise gas field – deciding that 80 per cent of it lies outside the JPDA (and hence belongs to Australia until boundaries are settled), and that the 20 per cent inside the JPDA would be split 90-10 for East Timor.

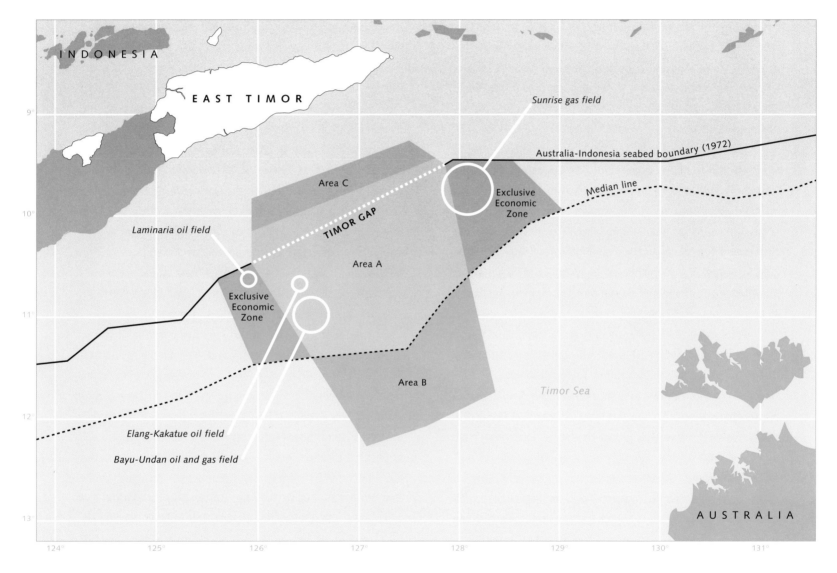

INDONESIA

EAST TIMOR

9°

Area C

Sunrise gas field

Australia-Indonesia seabed boundary (1972)

Median line

10°

TIMOR GAP

Laminaria oil field

Exclusive
Economic
Zone

Area A

Exclusive
Economic
Zone

11°

Area B

Timor Sea

12°

Elang-Kakatue oil field

Bayu-Undan oil and gas field

13°

AUSTRALIA

124° 125° 126° 127° 128° 129° 130° 131°

Area A East Timor-Australia Joint Petroleum Development Area

Area B Australian jurisdiction

Area C East Timorese jurisdiction

East Timor's parliament passed a maritime boundaries law in October 2002, claiming a 200-nautical mile Exclusive Economic Zone (EEZ) in all directions, but subject to future negotiations with Indonesia and Australia. Two months later, it ratified the Timor Sea Treaty. Canberra's ratification in March 2003 brought the treaty into effect. Also in March, Australia bullied East Timor into accepting a Sunrise Unitization Agreement (IUA), which, for the foreseeable future, locks in Australia's control of that project – the largest gas field in the Timor Sea – and an 82 per cent share of its revenues when production starts after 2009.

The Timor Sea Treaty and the Sunrise Unitization Agreement purport to be "without prejudice" to future boundary settlement, but they remain in effect for thirty years if boundaries are not agreed to. The Australian government, with belated dissent from the Parliamentary opposition, has made it clear that it sees Australia's national interest as maximizing its take from East Timor's resources – which means keeping the boundaries undefined and the interim TST and IUA in effect for as long as there is oil and gas under the Timor Sea.

After more than a year of stalling, Australia finally sat down at the table with East Timor for preliminary maritime boundary discussions in November 2003. Although East Timor requested monthly meetings, Australia refused to meet for another six months, and has made it clear that these issues could take a very long time to resolve. East Timor has asked Australia to stop development and exploitation of oil resources claimed by both countries but outside the JPDA, but Australia has ignored the request. The most important such field is Laminaria-Corallina, which has generated more than US$1 billion in revenues for Australia since it began production in 1999. This field will be exhausted by 2005, and East Timor has not received one cent from it.

East Timor has learned that there is no justice when billions of dollars are in play.

During its first year of independence, public expenditures in East Timor were approximately US$254 million, of which $85 million was from the government budget, and the rest in programs managed directly by foreign governments and institutions. About 40 per cent of the $85 million government income is from foreign donors through a World Bank-controlled financing mechanism. Locally raised non-oil revenues are about $20.8 million, with oil revenues of about $21.3 million – before any of the major fields have started producing. By 2006-2007, non-oil revenues are projected to remain about $21.2 million, with oil rising to $58 million and increasing thereafter. Because of technical delays in the Bayu-Undan project, East Timor's oil income during 2005-2007 will be far less than projected. This is causing huge problems for East Timor's government budget, probably forcing the debt-free new nation to borrow from the World Bank or the IMF. A few years later, when Sunrise and Bayu-Undan phase 2 come on line, oil revenues will surpass East Timor's government expenditures, and the surplus will be placed in reserve to provide for the country in the post-oil period.

Even with aid and oil, East Timor's government cannot provide free public education or widely available health care. Transportation, water, electricity, and communications infrastructure remain nonexistent in much of the country and substandard everywhere. If East Timor gets the revenues allocated under the Timor Sea Treaty and Sunrise IUA the country will, at best, be able to raise its standard of living to an Asian average – better than Indonesia but worse than Thailand. Without this money, the country will remain the poorest in the region.

But if the rule of law prevails, and Australia decides to be a good global citizen, East Timor's future is more hopeful. Income from the oil and related developments, as well as educational and other opportunities bootstrapped on the industry, could enable East Timorese, in time, to enjoy services comparable to those available to middle-class Australians or

Canadians – with health, energy, education, and leisure. If East Timor can control its own oil resources, it can manage the downstream projects – pipelines, liquefaction plants, refineries, distribution – to provide the maximum economic benefit and minimal destructive effects for its people and environment.

This dream (not an impossible one) will be difficult to achieve, and will take not only Australian co-operation but also East Timorese wisdom. East Timor's government will have to resist pressures from the World Bank and its allies to surrender economic control to foreign private companies. And they must manage their temporary windfall well, using two decades of wealth to provide for future generations.

Around the world, multinational oil companies like those running Timor Sea operations are accompanied by corruption, conflict, repression, and local and global environmental devastation. As the history of East Timor and the current situation in West Papua and Aceh demonstrate, underground wealth often induces above-ground violence. Furthermore, countries whose economies depend on extractive industries usually have higher rates of poverty and inequality.

East Timor's government sees the Timor Gap as an alternative economic resource for the country. It wants the oil and gas revenue to fill the budget gap between aid and expenditure and provide self-sufficiency for future development.

But for many East Timorese, particularly for those who lost their families and their dignity, the Timor Gap is an issue of national sovereignty and recognition of the rights of the nation. For them, sovereignty means that East Timor as a nation must be respected, and the dignity of the people restored by their right to control their land, sea, and natural resources. In the context of national liberation, the Timor Gap issue illustrates the priority of defining the sovereign nation by defining the maritime boundaries between Australia and East Timor. In a democratic and legal world order, preached to East Timor by so many international agencies doing civic education since 1999, this can only be determined by East Timor's national maritime boundary claim (a 200-mile EEZ), as negotiated and arbitrated according to the principles of the United Nations Convention on the Law of the Sea. ■

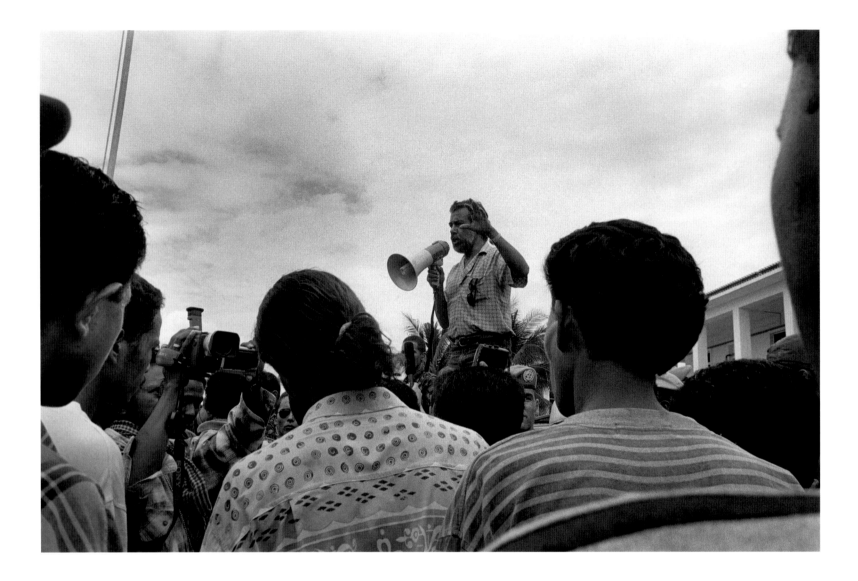

104 Xanana Gusmão speaking to youth seeking work, 2000

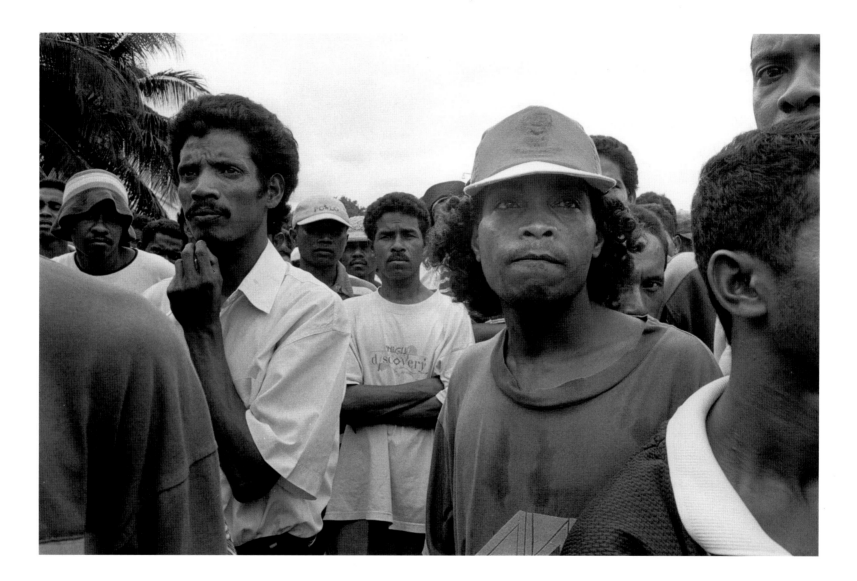

Youth listening to Xanana Gusmão, 2000

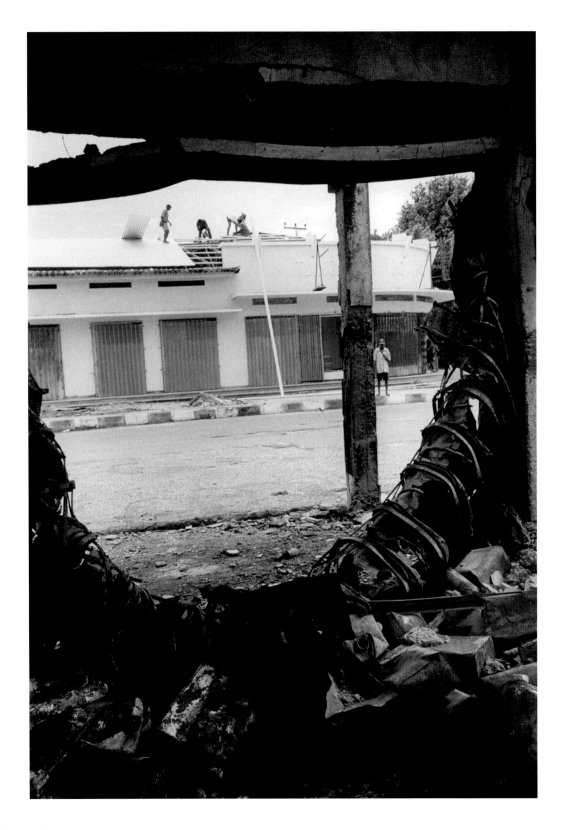

Destruction of Dili, 2000

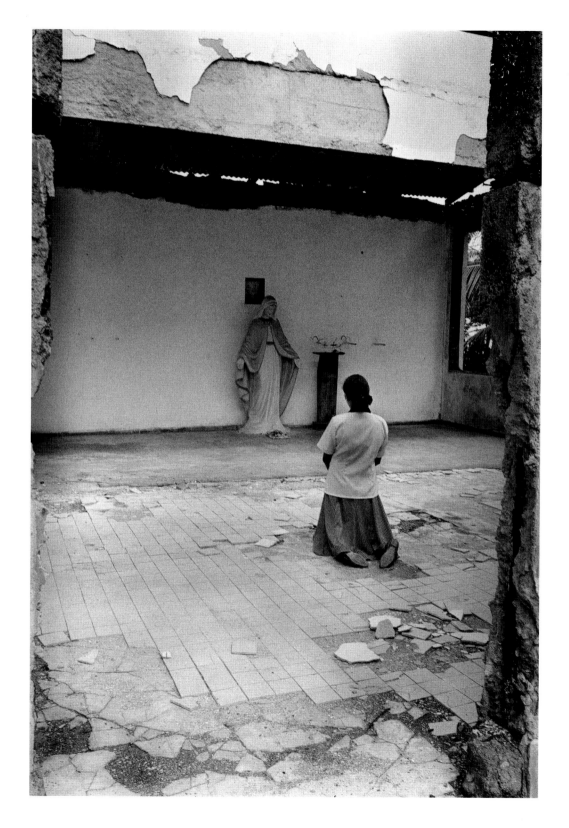

Woman praying in ruins of Bishop Belo's house, Dili, 2000

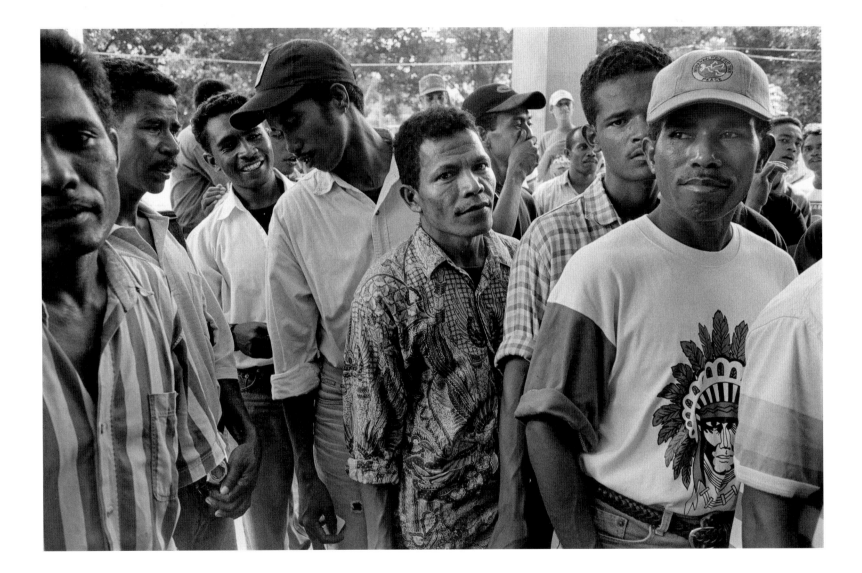

Job market, Dili, 2000

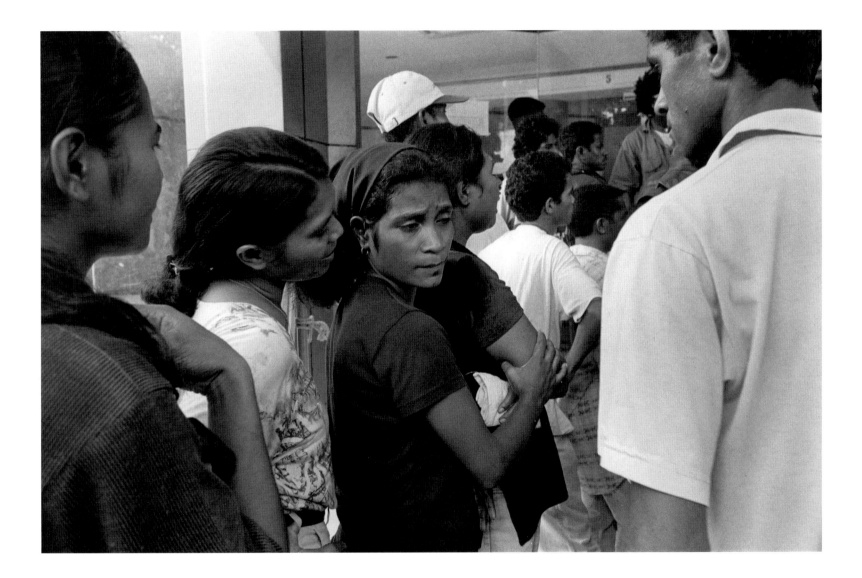

Job market, Dili, 2000 109

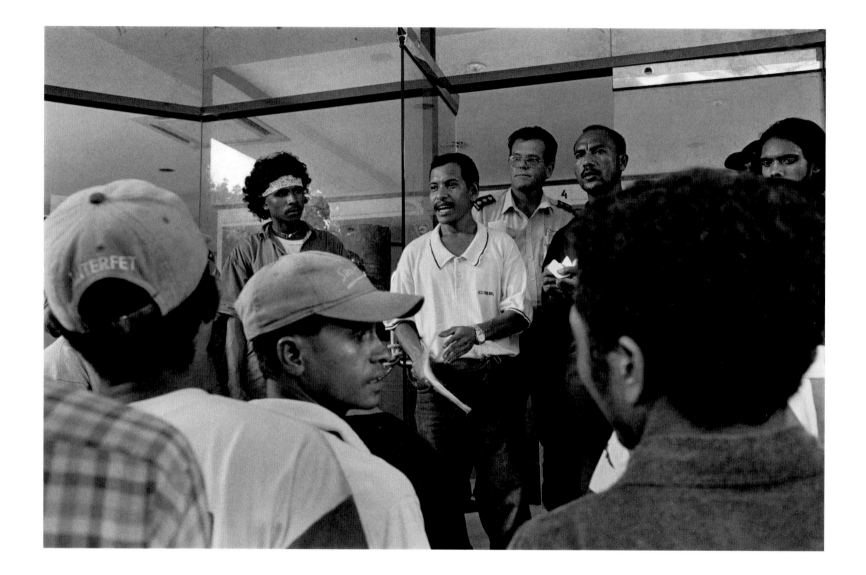

Job market, Dili, 2000

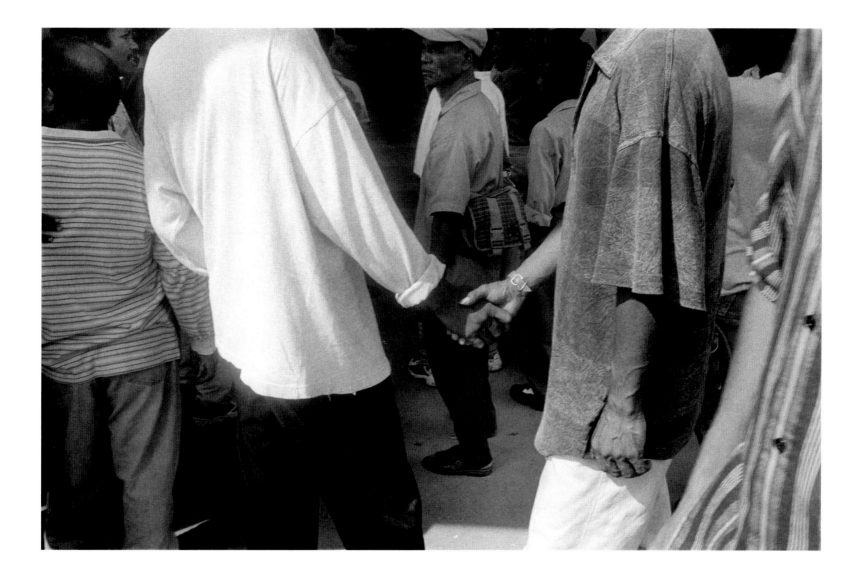

Job market, Dili, 2000 111

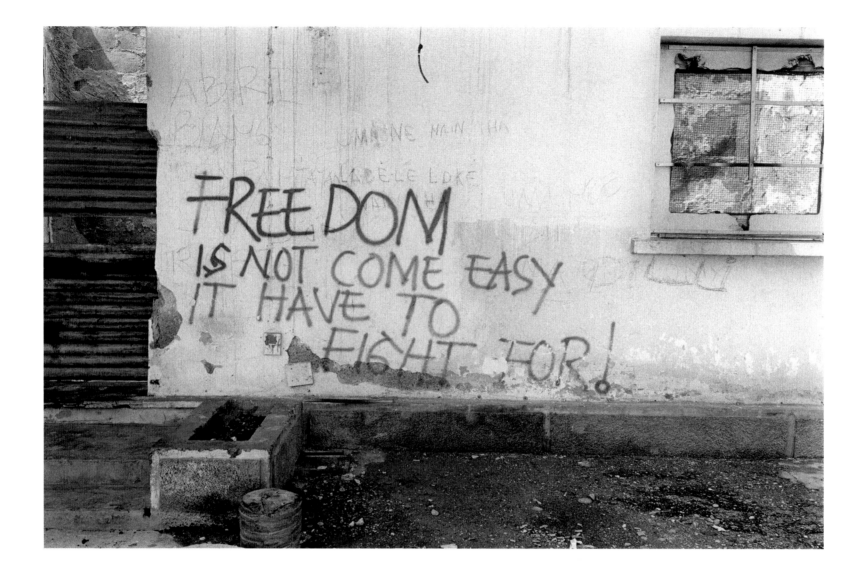

Graffitti, Dili, 2000

CHRONOLOGY

The fall of the Salazar-Caetano dictatorship in Portugal sets the colonies on the path to self-determination. Political parties begin to be formed in East Timor.

June 17, 1974

Indonesian foreign minister Adam Malik promises to respect East Timor's right to self-determination.

April 1974

Elaine Brière visits East Timor and takes a series of photographs that become the last visual record of pre-invasion East Timor.

November 28, 1975

One of East Timor's political parties, Fretilin, declares an independent Democratic Republic of East Timor.

December 7, 1975

Indonesian forces invade East Timor immediately after a visit to Jakarta by US president Gerald Ford and Secretary of State Henry Kissinger. On December 22, the UN passes the first of ten resolutions supporting East Timor's right self-determination. The US and other countries continue to supply arms to Indonesia.

July 17, 1976

Indonesia declares East Timor to be its twenty-seventh province. By this time, 60,000 Timorese have died. The death toll will eventually reach 200,000 or more.

October 1979

The Red Cross is finally allowed to begin a relief program in East Timor. Aid workers describe widespread famine and suffering.

1986

The East Timor Alert Network (ETAN) is formed in Canada. It becomes part of an international solidarity network that will eventually include groups in thirty-one countries.

November 1988

The Indonesian government ends East Timor's status as a closed territory and begins to allow access.

February 6, 1989

East Timor's Bishop Carlos Belo writes to the UN asking for a referendum on independence.

October 12, 1989

Pope John Paul II holds a mass in Dili. At the conclusion, pro-independence banners are raised by the crowd, and Indonesian forces beat protesters as the Pope looks on.

December 11, 1989

Australia and Indonesia sign the Timor Gap Treaty, divvying up the offshore oil of the Timor Sea. As part of the price, Australia officially recognizes East Timor as an Indonesian province.

November 12, 1991

Indonesian forces open fire on a pro-independence demonstration, killing 273 people. What becomes known as the Santa Cruz massacre is witnessed and captured on film that is screened around the world. International solidarity begins to increase. Canada is one of three countries to suspend planned aid projects for Indonesia.

November 20, 1992

East Timorese resistance leader Xanana Gusmão is arrested. He continues to lead the resistance from an Indonesian prison cell, enhancing his status as "East Timor's Nelson Mandela."

November 1994

29 Timorese students enter the US Embassy in Indonesia during the Asia Pacific Economic Cooperation (APEC) summit, putting East Timor on front pages around the world.

October 1, 1996

The Norwegian Nobel Committee announces that the 1996 Nobel Peace Prize will be awarded to Bishop Carlos Belo and East Timorese diplomat José Ramos Horta.

November 1997

Activists in Vancouver try to serve citizens' arrest warrants on Indonesian President Suharto, in town for the APEC summit.

May 20, 1998

Indonesian President Suharto is forced to resign amidst economic crisis and pro-democracy protests, ending a thirty-two-year dictatorship. Free elections are promised for Indonesia.

March 11, 1999

The UN announces that Portugal and Indonesia have agreed to a referendum allowing East Timor to choose autonomy within Indonesia or independence. The Indonesian army remains responsible for security, and begins to train and arm militia groups to thwart the ballot.

August 30, 1999

More than 98 per cent of registered voters take part in the UN-sponsored referendum. When the results are announced, 78 per cent have opted for independence. For two weeks, a reign of terror engulfs East Timor as militia and Indonesian soldiers stage attacks on churches, civilians, and international monitors. Hundreds of thousands of Timorese are forcibly relocated to Indonesian West Timor.

Under heavy international pressure, Indonesia agrees to an international peacekeeping force. Troops begin to arrive from Australia on September 20. East Timor is soon placed under temporary UN rule.

Elaine Brière makes a return visit to East Timor.

East Timor becomes the first new state of the twenty-first century. It faces a legacy of poverty and destruction resulting from the Indonesian occupation and the 1999 violence.

ORGANIZATIONS IN SOLIDARITY WITH EAST TIMOR

La'o Hamutuk
The East Timor Institute for
Reconstruction Monitoring and Analysis

PO Box 340
Dili, East Timor
Tel. +670-3325013 Mobile +670-7234330
www.etan.org/lh
laohamutuk@easttimor.minihub.org

International Federation for East Timor

PO Box 1182
White Plains, New York 10602, USA

TAPOL: The Indonesia Human Rights Campaign

111 Northwood Road
Thornton Heath, Surrey CR7 8HW, England
Tel: +44-20-8771-2904
fax: +44-20-8653-0322
tapol@gn.apc.org
www.gn.apc.org/tapol

TAPOL Canada

PO Box 562, Station P
Toronto, Ontario
M5S 2T1
Canada
maggie@web.ca

East Timor Action Network (ETAN/US)

48 Duffield Street
Brooklyn, NY 11201, U.S.A.
etan@etan.org
www.etan.org

NOTES ON THE CONTRIBUTORS

Award-winning photographer and documentary filmmaker Elaine Brière has been involved with the Timorese struggle for independence for thirty years. Her film *Bitter Paradise: The Sell-Out of East Timor* was named Best Political Documentary at the 1997 Hot Docs! Festival in Toronto. She is based in Vancouver.

David Webster worked with the East Timor Alert Network starting in the 1980s, and has written extensively about East Timor. He is currently completing a doctorate in history at the University of British Columbia.

Merício "Akara" Juvenal dos Reis was born in Lospalos, East Timor, and graduated in anthropology from the University of Indonesia in 2001. He joined La'o Hamutuk the same year, and married Endah Pakaryaningsih in 2002. Dos Reis focuses on popular education, human rights, international exchanges, and gender issues.

Endah Pakaryaningsih was born in Blora, Indonesia, and graduated in nursing from the University of Indonesia in 2000. She worked as an editor and translator at EGC Medical Publishers in Jakarta until 2002. She lives in East Timor with her husband, Merício dos Reis.

Constâncio Pinto was elected Secretary of the Executive Committee of the National Council of Maubere Resistance (CNRM) in the Clandestine Front in 1990. He was arrested and tortured by the Indonesian police and went into hiding. In 1992, after helping to organize the Santa Cruz Cemetery protest, Pinto escaped to Indonesia and then travelled to Singapore, Hong-Kong, Macao, and Portugal. Pinto worked tirelessly with solidarity movements to mobilize public support for the East Timorese struggle for independence. He co-authored *East Timor's Unfinished Struggle* (South End Press, 1996) with Matthew Jardine. He is currently Minister-Counselor for East Timor in Washington D.C.

Noam Chomsky writes and lectures widely on linguistics, philosophy, intellectual history, contemporary issues, international affairs, and US foreign policy. A professor at the Massachusetts Institute of Technology, he holds dozens of honorary degrees.

Chomsky is a recipient of the Distinguished Scientific Contribution Award of the American Psychological Association, the Kyoto Prize in Basic Sciences, the Helmholtz Medal, the Dorothy Eldridge Peacemaker Award, the Ben Franklin Medal in Computer and Cognitive Science, and the Adela Dwyer/St. Thomas of Villanova Peace Award.

Carmel Budiardjo worked as an economics researcher at the Indonesian department of Foreign Affairs in Jakarta from 1955 to 1965. She was active in a left-wing organization of academics, the HSI, and in the Indonesian Communist Party. Under Suharto, both she and her Indonesian husband were arrested and imprisoned. Budiardjo was expelled in 1971. In 1973 in Britain she helped to found TAPOL, a campaign for the release of political prisoners in East Timor. Budiardjo has written several books with co-author Liem Soei Liong, including *The War Against East Timor*, *West Papua: The Obliteration of a People*, and *Muslims on Trial,* as well as an account of her prison experiences, *Surviving Indonesia's Gulag.* Budiardjo was awarded the Right Livelihood Award (the alternative Nobel Prize) in 1995.

James Dunn is a foreign affairs specialist whose experience with East Timor goes back to 1962, when he was appointed Australian consul there. He returned on an official fact-finding mission in 1974, and again in 1975 as the head of an aid mission. Since 1999 he has served with UN missions as an expert on crimes against humanity. Dunn is the author of three books on East Timor.

Before the Indonesian military destroyed the University of East Timor in September 1999, Inês Martins was studying economics there. She was born in Bobonaro, East Timor. Martins has worked with ETWAVE, a local NGO that focuses on the human rights of women and children, and since May 2000, with La'o Hamutuk. She is active in Dai Popular, the Association of Popular Educators.

Andrew Teixeira de Sousa is a grassroots activist from the United States, where he was involved in economic and social justice movements and co-founded the Arizona chapter of the East Timor Action Network. From 2001 to 2003 he worked at La'o Hamutuk in Dili, focusing on international financial institutions and markets. De Sousa has also worked on gender issues in East Timor with the Association of Men against Violence.

Adriano do Nascimento was targeted by militia before the Timorese referendum and forced to leave his hometown; he went overseas to campaign for independence. In 1989 he co-founded Conflict Management Group, a national NGO now known as the Kdalak Sulimutu Institute. Do Nascimento worked at La'o Hamutuk from 2001 to 2003 and helped organize the Independent Centre for Timor Sea Information. Currently, he is a Senior Program Officer with Catholic Relief Services Timor Leste, in their Peace Building and Reconciliation program.

Charles Scheiner has been a peace and justice activist in the United States since the Vietnam War. He was National Co-ordinator of the East Timor Action Network (ETAN/U.S.). Beginning in 1992 he was UN representative from the International Federation for East Timor (IFET), while also working as a software engineer. In 2001, Scheiner moved to East Timor and joined La'o Hamutuk, where he focuses on oil and gas issues, justice, and encouraging the international solidarity movement to continue to support the new nation.